MW00603580

IMAGES
of America

THE BUILDINGS OF FRANK LLOYD WRIGHT AT FLORIDA SOUTHERN COLLEGE

Fall 2011

Welcome to FSC, Mia!

♡ΠΚΕ,

The Sisters of Eta Beta

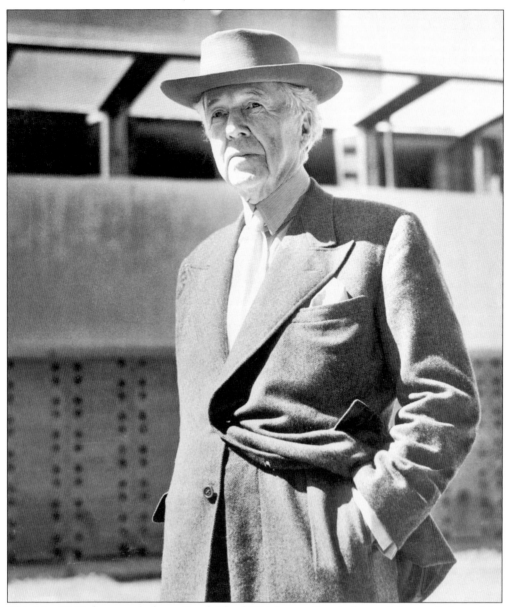

This May 1942 photograph shows Frank Lloyd Wright standing in front of the north face of the Annie Pfeiffer Chapel, his signature building at Florida Southern College. His Child of the Sun campus collection, constructed between 1938 and 1958, helped establish the college's reputation internationally and draws thousands of visitors to Lakeland. (Courtesy Dan Sanborn, Special Collections, Lakeland Public Library, Lakeland, Florida.)

ON THE COVER: An art student seated at the south end of the Benjamin Fine Administration Building paints this early 1950s panorama. When the building was completed in 1949, students visiting the offices of the registrar and bursar located in it had a clear view through tall casement windows that opened from the main lobby and an office. A version of this photograph was used in college publicity brochures throughout the 1950s. (Courtesy Florida Southern College.)

IMAGES
of America

THE BUILDINGS OF FRANK LLOYD WRIGHT AT FLORIDA SOUTHERN COLLEGE

Randall M. MacDonald,
Nora E. Galbraith, and
James G. Rogers Jr.

ARCADIA
PUBLISHING

Copyright © 2007 by Randall M. MacDonald, Nora E. Galbraith, and James G. Rogers Jr.
ISBN 978-0-7385-5279-8

Published by Arcadia Publishing
Charleston SC, Chicago IL, Portsmouth NH, San Francisco CA

Printed in the United States of America

Library of Congress Catalog Card Number: 2007925236

For all general information contact Arcadia Publishing at:
Telephone 843-853-2070
Fax 843-853-0044
E-mail sales@arcadiapublishing.com
For customer service and orders:
Toll-Free 1-888-313-2665

Visit us on the Internet at www.arcadiapublishing.com

RMM: To Susan Priest MacDonald and Sarah Elizabeth MacDonald, with whom I have explored the Florida Southern campus for 21 and 19 years.

NEG: Special thanks to Dave Galbraith for his love, patience, and encouragement, and thanks to all of my family for their support.

JGR: To my family and friends, who put up with my obsessions with wonderful, threatened, and sometimes quixotic projects like the Child of the Sun campus.

CONTENTS

Acknowledgments 6

Introduction 7

1. Annie Pfeiffer Chapel 9

2. Seminar Buildings and the Esplanade 37

3. E. T. Roux Library 47

4. Administration Buildings and the Waterdome 67

5. Lucius Pond Ordway Building 83

6. William H. Danforth Chapel 99

7. Polk County Science Building 109

Bibliography 127

ACKNOWLEDGMENTS

The inspiration for this project may be traced to the enthusiasm for Frank Lloyd Wright's magnificent work shared with us by two late Florida Southern College colleagues, Raymond H. Fischer, class of 1972, and Louise W. Eastwood, class of 1951. Ray and Louise were extraordinary ambassadors for the college, and they are missed.

To our colleagues and friends at Florida Southern, we appreciate your affable spirit and commitment to excellence. This project would not have materialized without Lynn M. Dennis, class of 1971, who has steadfastly championed Frank Lloyd Wright programs at the college. Kind assistance was also received from Pres. Anne B. Kerr; Lynne A. Bentley; Richard R. Burnette Jr.; Susan P. Conner; V. Terry Dennis; Mossayeb Jamshid; Wayne Koehler, class of 1983; Malcolm M. Manners; Kathy Moss; John E. Santosuosso; Patrick L. Smith; and Shari Szabo, class of 1983— our thanks to you all. Alumnus Raleigh Bailey, class of 1965, provided enjoyable reflections of his years at Florida Southern, and for their encouragement, we acknowledge Joy Banks, Mary M. Flekke, Sally Gullage, Fran Lippincott, Eridan J. McConnell, Ann Rogers, and Debbie Rusch. Andrew L. Pearson was supportive throughout the project.

Sarah E. MacDonald provided material assistance in the preparation of the manuscript and helped conduct a building-by-building assessment of structural changes. Avid photographer William Carpenter graciously shared his spectacular campus images. Librarian Sandy Kline of *The Ledger* helped secure photograph reproduction permission. Kevin Logan and Ruth Snyder of the Special Collections department of the Lakeland Public Library provided research assistance and access to marvelous images. We appreciate their generosity and interest.

Arcadia Publishing has been wonderful to work with, from our initial conversations with Ingrid Powell, to the cheerful guidance of Kate Crawford. Our thanks also to Lauren Bobier, Maggie Bullwinkel, Nancy Collins, Marissa Foster, Barbie Langston Halaby, Emily Miller, P. J. Norlander, and Doug Rogers.

A grateful thanks is also extended to James V. Bavinger, Antonio Castellvi, Ann Marie Gowski, Carlos Guzman, Sean P. O'Rourke, Patricia A. Rouleau, and R. Paul Rouleau. For a time, the future of this project rested in their hands.

INTRODUCTION

In the center of Lakeland, Florida, the remarkable campus of Florida Southern College is home to the world's largest single-site collection of structures designed by Frank Lloyd Wright.

In 1932, during the depths of the Depression, Wright, at the age of 65, sought to rebuild his career and his national reputation with the founding of his school of architecture, the Taliesin Fellowship, at Taliesin, his country home in Spring Green, Wisconsin. In 1936, Wright's sensational design for the Fallingwater house, built outside of Pittsburgh, Pennsylvania, for department-store owner Edgar J. Kaufmann Sr., put him on the cover of *Time* magazine. Florida Southern College's president, Dr. Ludd Mryl Spivey, met with Wright at Taliesin in April 1938 as part of Spivey's ambitious building program to transform the small Methodist school from "the college on a hill, by a lake, in an orange grove" into a national showplace. The two men forged an agreement that led Wright to eventually design 18 structures for the Florida Southern campus, 12 of which were built.

Frank Lloyd Wright made his first visit to Lakeland a month after Dr. Spivey's visit. Wright is reported to have strolled through the gently sloping former orange grove that was the campus, pausing to let the sandy soil run between his fingers. Wright then began to formulate plans for a college he described as "unequaled in the beauty of use or the use of beauty anywhere on earth." Wright saw buildings growing "out of the ground into the light—a Child of the Sun." What followed were two productive decades of work at the college. The structures completed were the Annie Pfeiffer Chapel (1938–1941); the Cora Carter, Charles W. Hawkins, and Isabel Walbridge Seminar Buildings (1941); the Esplanade (1940–1958, 1969); the E. T. Roux Library (1941–1945); the Emile E. Watson and Benjamin Fine Administration Buildings (1946–1948); the J. Edgar Wall Waterdome (1947–1948); the Ordway Industrial Arts Building (1950–1952); the William H. Danforth Chapel (1954–1955); and the Polk County Science Building (1953–1958).

Wright's work at Florida Southern College became an important part of his second career (1932–1959), a period that ensured his reputation as one of the world's most significant architects. During these years, after an age when most men had retired, Wright and the Taliesin Fellowship produced some 400 projects, including some of the most famous buildings in the world: Fallingwater (1936), the S. C. Johnson Administration Building (1936), Taliesin West (1937–1956), the V. C. Morris Gift Shop (1948), the Price Company Tower (1952–1956), the Solomon R. Guggenheim Museum (1943–1959), and Florida Southern College (1938–1958). The Florida Southern campus is one of Wright's projects of longest duration and one of a handful of projects that Wright specifically cited as important.

Frank Lloyd Wright's work at Florida Southern College involved placing and connecting a group of buildings in the landscape, an approach that he also took at Taliesin East and West, and at the Marin County Civic Center. In each instance, Wright used thematic elements—largely geometric—which he combined and recombined in ongoing, visually harmonic iterations to create the three-dimensional equivalent of a symphony. An accomplished pianist, Wright spoke of the mathematical analogies between music and architecture. Rhythmic walkways lead both

the eyes and the feet from structure to structure and from outside to inside. Structural forms call back and forth from building to building like orchestrated instruments. Particularly at Florida Southern College, Wright's symphony is all around.

What has become of Wright's campus? The demands of a growing student body placed a tremendous strain on Wright's buildings; there were approximately 500 students in 1938, but the number reached a peak of more than 2,300 students in 1956. Subsequent buildings altered the sense of space surrounding Wright's works. A new library was constructed north of the Waterdome between 1966 and 1968, and Wright's original E. T. Roux Library was restructured for office space, with only the circular reading room remaining recognizable inside. The seminar buildings were extensively altered and enclosed as one larger building, to the point that it is difficult to envision them as separate buildings. Another significant modification was to the Waterdome, which was partially filled and covered with a concrete plaza, to form a large court with four pools. Most seriously, damage from the elements has not been kind to Wright's structures. The materials at his disposal were susceptible to the extremes of Florida's climate, and the buildings require ongoing care.

Thankfully appreciation for Frank Lloyd Wright's work has grown and, with it, attention to his buildings at Florida Southern. Work to restore the Waterdome was initiated in 2006, and, for the first time in 40 years, it is possible to view this magnificent space as Wright intended. Simultaneously, the college received a Campus Heritage Grant from the J. Paul Getty Foundation to develop a preservation master plan to establish guidelines for long-term stewardship of the 12 Frank Lloyd Wright structures on the Florida Southern campus. The Wright buildings were included on the World Monument Fund's 2008 World Watch List, a body of architecturally significant sites in urgent need of immediate attention and assistance, and worthy of preservation. At long last, students, faculty, staff, and visitors will once again be able to fully appreciate one of Wright's most outstanding works of genius.

Drawn from the archives of Florida Southern College and other local collections, these photographs trace the construction and evolution of Florida's most celebrated architectural collection and pay tribute Frank Lloyd Wright.

One

ANNIE PFEIFFER CHAPEL

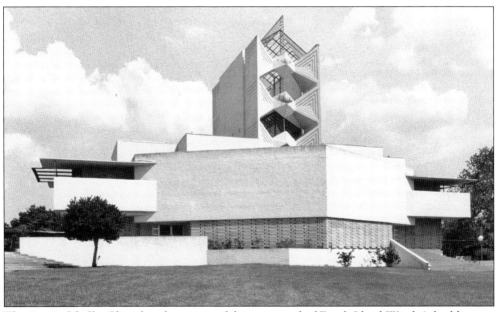

The Annie Pfeiffer Chapel is the most widely recognized of Frank Lloyd Wright's buildings at Florida Southern College. Constructed between 1938 and 1941 at a cost of $100,000, it became the physical and spiritual center of Wright's Child of the Sun campus collection. Approximately 6,000 tapestry blocks in 46 different designs were cast on-site from a coquina and concrete mixture to form the exterior walls. (Courtesy Florida Southern College.)

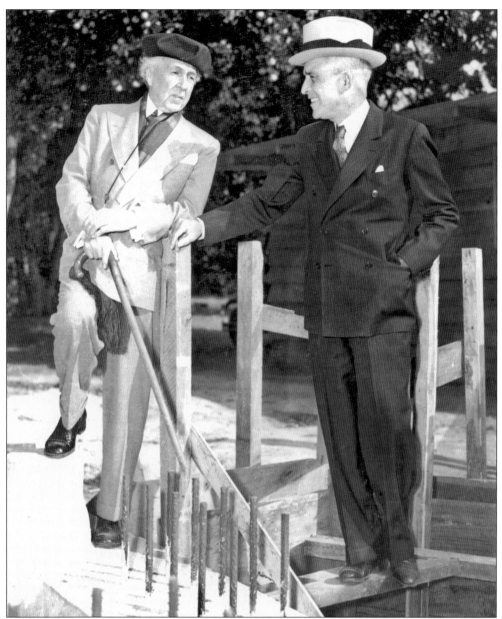

The student newspaper, *The Southern*, reported on Frank Lloyd Wright's December 20, 1938, campus visit: "In company with Dr. Ludd M. Spivey, Mr. Wright inspected the concrete and steel foundations of the chapel and discussed construction plans for the immediate future. Immaculately dressed, the master of Taliesin had his inevitable beret and cane with him when he discussed the project, which is expected to be the masterpiece of his career. 'The buildings will be an architectural unit related each to each and each to all, a harmonious whole expressing the spirit of the college free from grandomania. The chapel will perhaps be the most spirited and spiritual expression of all the buildings. [A] chapel building is a thing of the spirit and for the spirit and best serves its purpose when the body is comfortable, which it never was in Gothic architecture.' The buildings are of a pattern indigenous to Florida and uniquely adapted to the work to be done in them." (Courtesy Special Collections, Lakeland Public Library, Lakeland, Florida.)

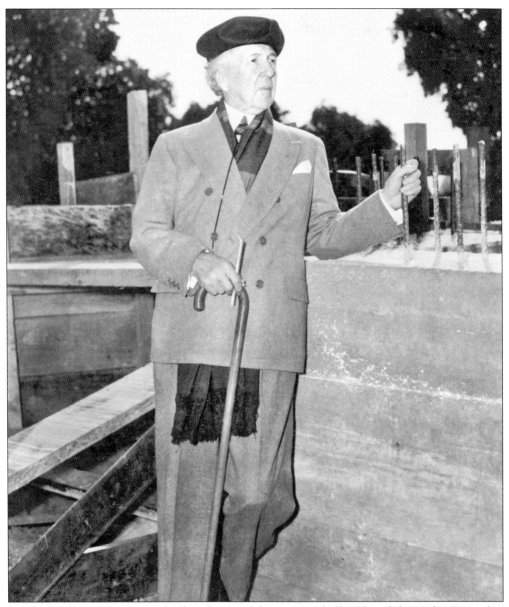

Frank Lloyd Wright inspects the foundation of the Annie Pfeiffer Chapel during his December 20, 1938, visit. The original building fund was developed in 1936 from work between Dr. Ludd M. Spivey and E. Stanley Jones, a noted author and missionary to India. Out of this collaboration grew the E. Stanley Jones Foundation and an early campus plan with traditional brick buildings to complement the extant dormitories and classroom building. Spivey traversed the state gathering pledges for the foundation, which continued to exist into the early 1940s. Eventually the partnership was dissolved. An April 1939 article in *The Southern* predicted that the chapel would be completed by September, but construction setbacks delayed the opening. According to the article, "The chapel will be 85-feet wide, 104-feet long, and 85-feet high, with chimes in the central tower." As built, the chapel was 65-feet tall, plus the height of the trellis, and the first floor measured 88 feet north to south, and 80 feet east to west. (Courtesy Special Collections, Lakeland Public Library, Lakeland, Florida.)

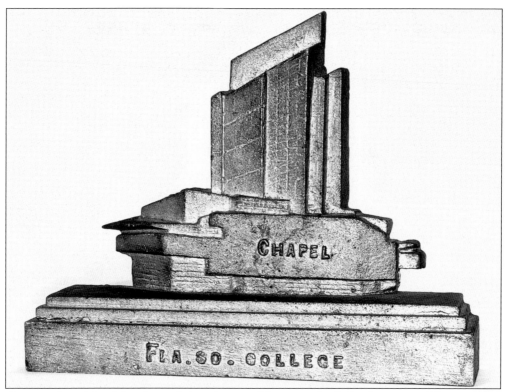

Cast-metal models of the planned chapel were sold to raise funds for the project. This model, a reasonable representation of the finished structure, is from the Raymond H. Fischer Collection, Florida Southern College. (Courtesy Nora E. Galbraith.)

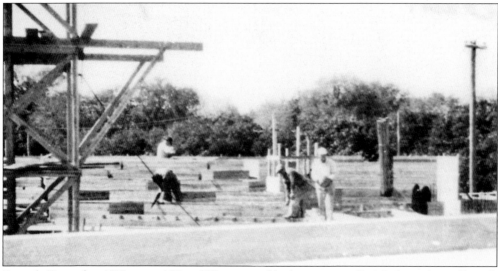

By early December 1939, some 150 to 200 tapestry blocks were installed daily as the walls took shape. The term "tapestry" refers to Frank Lloyd Wright's unique concrete-block system in which a series of large matching grooves running along the center of the sides, tops, and bottoms of the blocks hold steel reinforcing bars and mortar such that there are no mortar joints at the face of the blocks. (Courtesy Florida Southern College.)

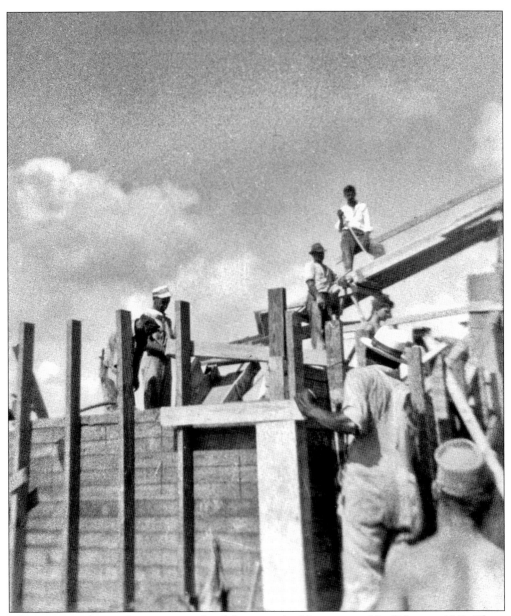

The concrete "bow tie" east-west ends of the tower had been poured by February 1941. There were no windows on the sidewalls of the completed chapel. Light streamed through the massive skylight, and the ground-level and balcony doorways helped illuminate the sanctuary during the day. The thousands of pieces of colorful decorative glass installed within the perforated tapestry blocks gave the chapel a jewel-box appearance. Shari Szabo, class of 1983 and daughter of Dean Frank Szabo, class of 1952, grew up on campus. "I remember as a little girl, I used to love to go to Annie Pfeiffer Chapel and imagine the colored pieces of glass were little jewels. Years later as a student and later as an employee of Florida Southern, I gained a totally different appreciation for his works on our campus. However, when I'm in Annie Pfeiffer Chapel, I still think of the glass as jewels as the light penetrates in through them. Jewels in a gem of a building." (Courtesy Florida Southern College.)

The land now home to Florida Southern College was once a citrus grove owned by A. P. McLeod, who cleared and planted the property in *c.* 1903. His daughter, Kate McLeod Breathitt, sold the property to the college in 1922, and many of her father's trees remained for decades. The last tree, a grapefruit, was removed *c.* 1978 and had a trunk 8.5 feet in circumference. Prior to Wright's arrival, there were only a handful of permanent buildings on the campus. Students played an integral role in the construction of his buildings. Lloyd G. Hendry, class of 1944, recalled that after his arrival as a freshman, he "soon settled into a pleasant routine of working on the Annie Pfeiffer Chapel on Mondays, Wednesdays, and Fridays, and attending classes on Tuesdays, Thursdays, and Saturdays." Robert D. Wehr, who had been a construction superintendent on Yankee Stadium, supervised construction of the Annie Pfeiffer Chapel, the seminar buildings, and the E. T. Roux Library. His assistant, Carl "Doc" Cunningham, was a retired dentist. Both men were remembered fondly. An unidentified student is seen in this early construction photograph. (Courtesy Florida Southern College.)

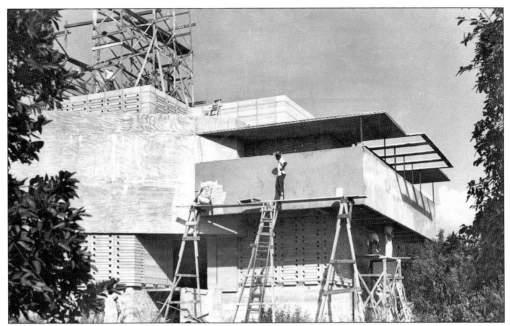

The chapel was designed to seat 1,000 people no one more than 50 feet from the pulpit. This view of the southwest corner underscores the undeveloped nature of the campus. Builders are seen here in this December 1940 photograph applying a stucco finish to the balcony. Scaffolding for the tower construction has been erected, and the bottom bow tie is visible. (Courtesy Florida Southern College.)

Progress on the tower suggests this photograph was taken during 1940. The west side of the building is shown with scores of blocks awaiting placement. The scaffolding included a pulley system to lift an enormous bucket used to pour the concrete structure. Even at this early point, a portion of the central skylight is already in place and visible. (Courtesy Special Collections, Lakeland Public Library, Lakeland, Florida.)

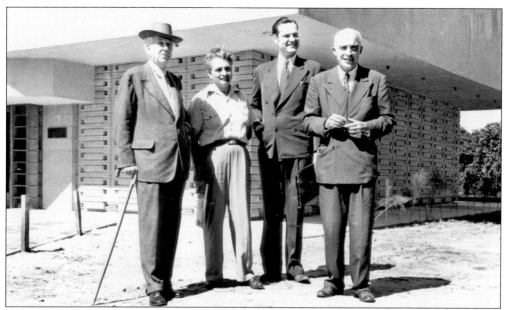

Standing outside the northeast main entrance to the Annie Pfeiffer Chapel are the men most responsible for its construction: Frank Lloyd Wright (architect), Robert D. Wehr (faculty member and construction superintendent), William Wesley Peters (Wright's protégé and on-site supervisor), and Dr. Ludd M. Spivey (college president). This photograph was probably taken in May 1942 during Wright's first trip to see the completed chapel. (Courtesy Florida Southern College.)

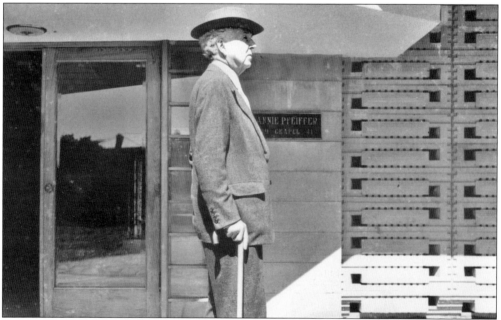

Frank Lloyd Wright is seen outside the northeast entrance of the chapel, probably during May 1942. The metal plaque adjacent to the entrance marks the structure: "Annie Pfeiffer/ 19 Chapel 41." According to a February 15, 1952, article in *The Southern*, the first man to speak in the chapel—in 1940, during construction—was noted Russian author George Grebenstchikoff, who later joined the college's faculty. (Courtesy Florida Southern College.)

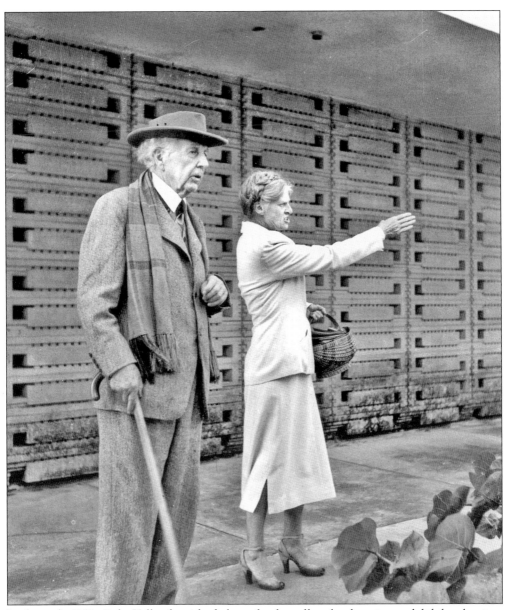

In the early 1950s, Reba Kelley furnished plants for the college landscaping and did the planting. Her plants were stored in a shade house south of the William H. Danforth Chapel and included crotons, hibiscus, ixora, and bougainvillea. A December 1957 freeze killed the crotons and the majority of the other tropical plants, and the campus was replanted with cold-tolerant plants. Frank Lloyd Wright and Kelley are seen here against the north face of the Annie Pfeiffer Chapel during his October 24, 1951, visit. When Wright received an honorary doctor of laws degree on March 3, 1950, he told the students, "This type of architecture can't mean much to you until you have had a good look at yourself. This architecture represents the laws of harmony and rhythm. It's organic architecture, and we have seen little of it so far. It's like a little green shoot growing in a concrete pavement. I don't believe you can build beautiful buildings . . . except from a worthy source, and that source is inevitably the human soul, the human heart." (Courtesy Florida Southern College.)

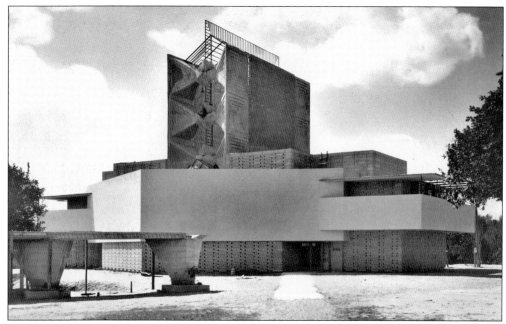

Carroll Teeter authored the earliest descriptive account of the finished chapel in April 1941 for *Dixie Contractor*. He wrote that Goodenough's Machine Shop in Winter Haven fashioned the block forms after Robert D. Wehr's design and that Carl Cunningham was in charge of block manufacturing. Heating was "supplied by copper coils embedded in gravel beneath the floor mat," through which hot water was pumped. (Courtesy Florida Southern College.)

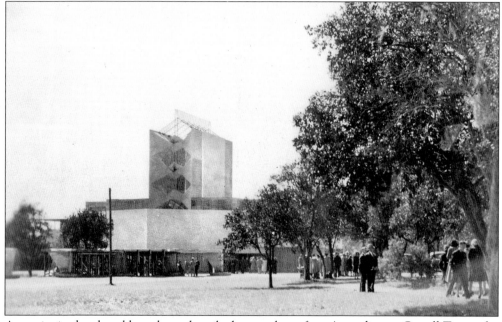

Acoustics in the chapel have been described as nearly perfect. According to Carroll Teeter, the acoustics are aided by "four 'sound wells' at the rear of each section of balcony seats. In appearance, like their name, the oblong wells extend through the mezzanine floor and permit sound waves access to all parts of the building with clarity." (Courtesy Florida Southern College.)

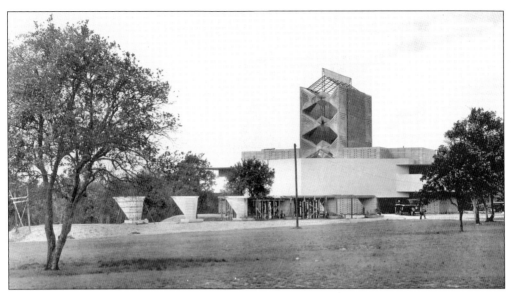

Blocks inside the south tower wall are visible in this photograph. The chapel was either complete, or nearly so, as plants grew in the tower planters, although the central skylight is not clearly distinguishable or not yet present. The chapel was described in the 1943 *Interlachen* yearbook as the "[s]cene of weekly chapels featuring speakers of honorific repute . . . student assemblies . . . concerts, lectures, and services at vesper time." (Courtesy Florida Southern College.)

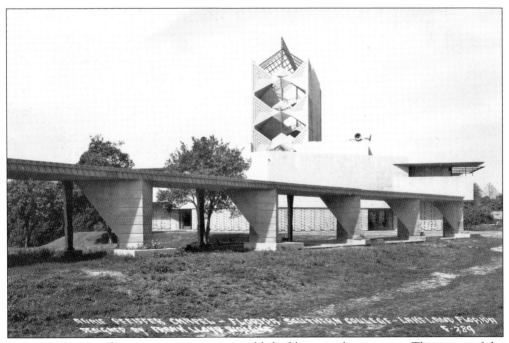

Postcards showing the growing campus were published by several companies. This image of the Annie Pfeiffer Chapel dates from after 1944, as the second-story tapestry blocks have been covered with stucco. Speakers atop each corner were connected to the chapel's organ so that music could be heard across the campus. The secondary support posts holding the Esplanade above a partially paved walkway are visible. (Courtesy Florida Southern College.)

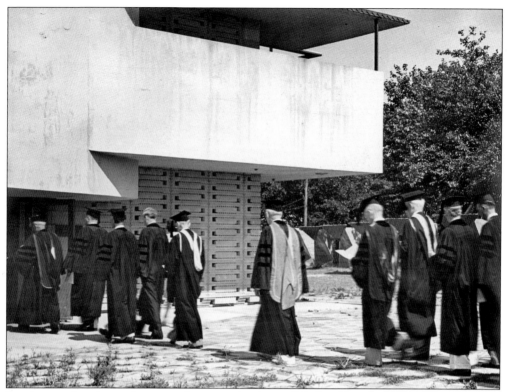

Faculty members in academic regalia enter the Annie Pfeiffer Chapel in the mid-1940s across hexagonal pavers. These pavers, custom-inscribed with donors' names and with four bands of color, varied slightly in size but were generally 2 feet, point-to-point, and 1 foot, 7 inches between straight sides. Five pavers may still be found near the patio pool between the administration buildings. (Courtesy Florida Southern College.)

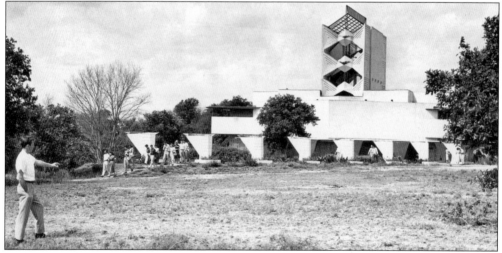

Students tread well-worn paths past the unfinished Esplanade east of the Annie Pfeiffer Chapel in the late 1940s or early 1950s. The Esplanade roof, or perhaps this entire Esplanade section, which had been evident in earlier photographs, had been removed, perhaps a victim of storm damage or construction flaws. (Courtesy Harold Sanborn, Florida Southern College.)

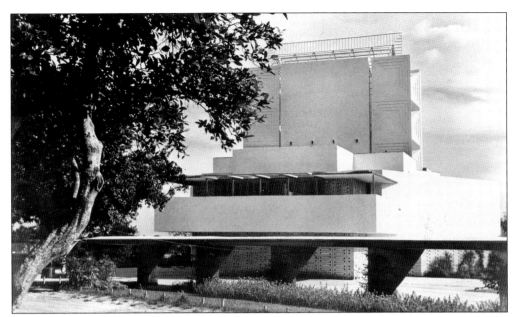

In the late 1940s, the north side of the Annie Pfeiffer Chapel was bordered by a dirt road. The chapel had been altered by this time because, after the October 1944 hurricane, the uppermost tapestry blocks had been covered with stucco, a necessary concession to Florida's wet climate. These Esplanade columns were inscribed with donors' names several feet from the ground in the direction of the chapel. (Courtesy Florida Southern College.)

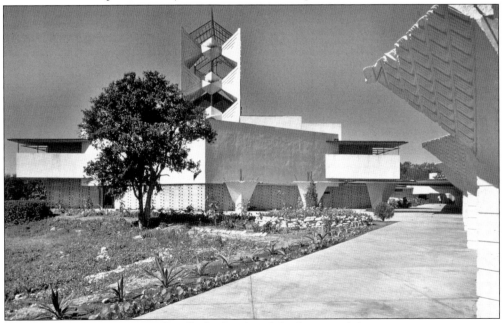

By the early 1950s, concrete sidewalks had replaced the hexagonal donor pavers across campus, which did not weather well. This photograph provides a clear view of the unfinished Esplanade, which at this time included columns heading south along the chapel wall, which would soon be covered. The E. T. Roux Library can be seen beyond the chapel and the plaza dotted with sea grapes. (Courtesy Florida Southern College.)

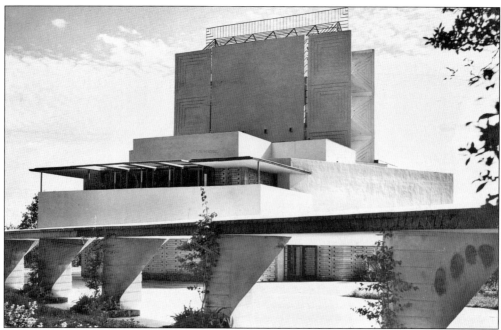

The Esplanade height between the Annie Pfeiffer Chapel and the E. T. Roux Library varies slightly but is generally 6 feet, 8 inches tall. The column centers here are just over 17 feet apart. In addition to providing all-weather access across the campus, the Esplanade physically and visually breaks up the campus and gives it a strong sense of picturesque space. (Courtesy Sanborn Photo Service, Florida Southern College.)

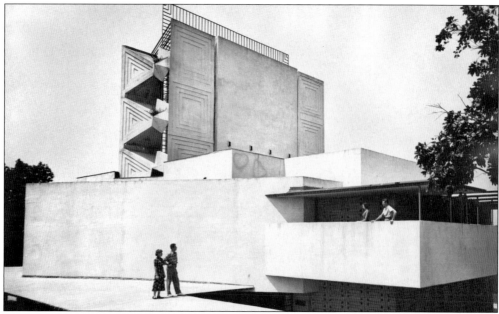

This promotional photograph shows students on the north Annie Pfeiffer Chapel balcony and on the Esplanade at the east side of chapel. Balcony access was eliminated after 1957 when air-conditioning ductwork was installed. The French doors to the balcony were replaced by low walls and casement windows. (Courtesy Harold Sanborn, Florida Southern College.)

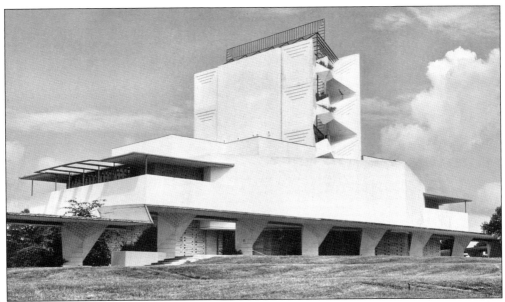

There are fewer photographs to be found of the east side of the Annie Pfeiffer Chapel. This view predates the installation of air-conditioning and the subsequent replacement of the Florida tidewater red cypress and glass doors. From this perspective, the adjoining Esplanade resembles a porch. (Courtesy Florida Southern College.)

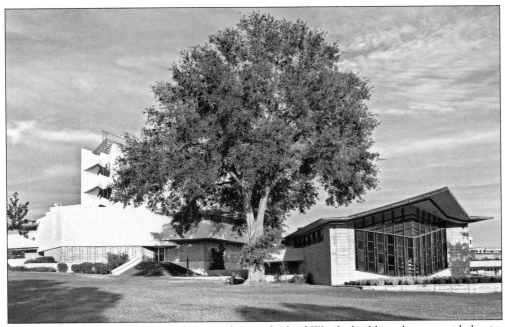

Shari Szabo, class of 1983, recalled that, "The Frank Lloyd Wright buildings have provided quite a connection to my family, from tales of my father's interaction with Mr. Wright in the 1950s, to my opportunity to provide tours for campus guests. My son [Sean Pera] was baptized in Danforth Chapel, and my father's funeral was in Annie Pfeiffer Chapel. They have been with my family from birth to death." (Courtesy William Carpenter.)

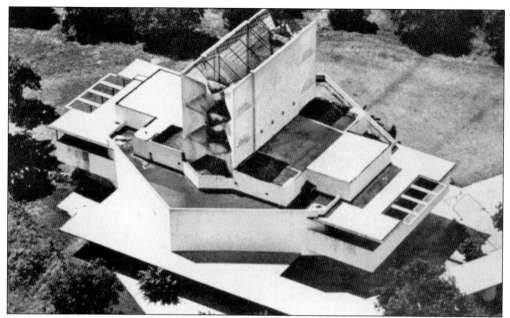

This aerial view of the Annie Pfeiffer Chapel, facing southwest, was published in the 1955 *Interlachen* yearbook. The photograph likely dates from the early 1950s, as the William H. Danforth Chapel is not shown. From this perspective, the reinforced concrete central tower looks less imposing than from the ground. Early plans illustrated a taller tower, with five east-west bow ties, rather than three. (Courtesy Florida Southern College.)

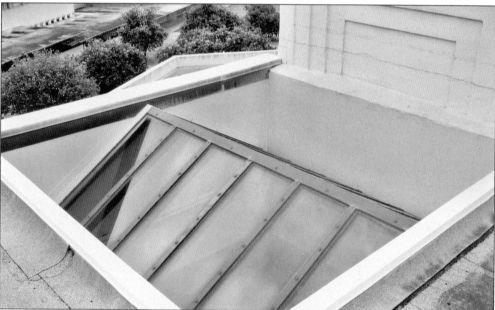

The Polk County Science Building is barely visible beyond this skylight at the northeast corner of the chapel, one of four small skylights flanking the massive central light. Two are above the west balcony, and two are above the choir loft. All four have been covered from beneath with framed covers, rendering them indistinguishable from below. An early photograph of one uncovered skylight is shown on page 35. (Courtesy Randall M. MacDonald.)

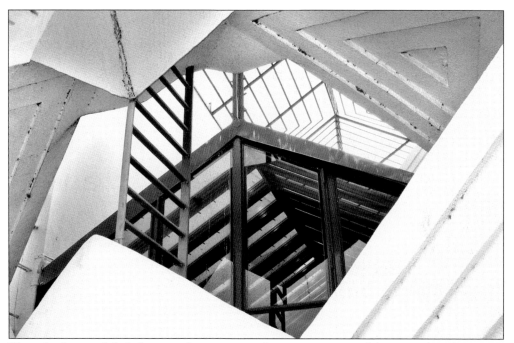

The ridged central skylight extends east to west between two sets of three reinforced concrete bow ties and flat walls extending upwards 23.5 feet from the roof. This photograph of the west end of the skylight shows a small trellis between the bottom and middle bow ties, designed to support cascading plants grown in integrated flower boxes. (Courtesy Randall M. MacDonald.)

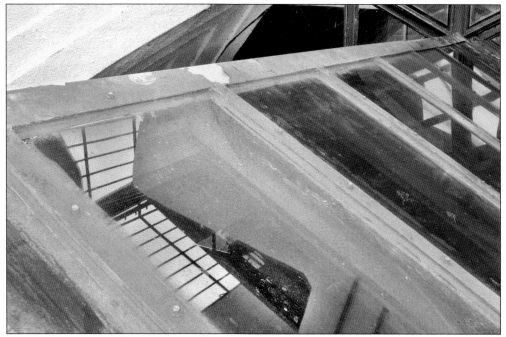

This unusual view of the west end of the central skylight shows the red metal framework of the current light. Seen in reflection is the trellis atop the chapel. The tower was designed to house 18 bronze, bell-shaped gongs. (Courtesy Randall M. MacDonald.)

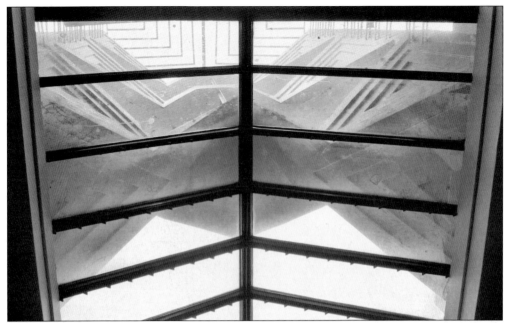

Viewed from inside the chapel, the west end of the skylight provides a clear view of the tower superstructure. The bow ties are connected to the vertical tower walls and, according to Carroll Teeter, were, along with the tower cornices, to be copper-blasted, "causing a contrast of the shining metallic surface with the flat, dull-tan plaster of the balcony sides." (Courtesy Randall M. MacDonald.)

Raleigh Bailey, class of 1965, recalled time spent in the chapel: "In the required freshman chapel services in Annie Pfeiffer Chapel, I used to spend much time looking up at the glass-encased, high-rise ceiling and wondering how anyone could wash those skylights. I also fretted over how to pull the weeds that seemed to grow profusely around those lofty skylights." This unusual view dates from the early 1940s. (Courtesy Florida Southern College.)

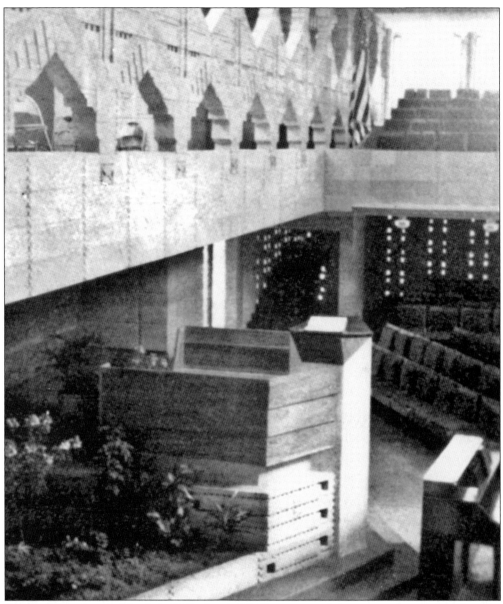

At the dedication on March 9, 1941, Annie Pfeiffer presented the extraordinary chapel to the college with the words, "They say it is finished." Representatives from 57 colleges and universities attended the festivities, acclaimed theologian and Florida Southern faculty member Shirley Jackson Case read Scripture, and the dedication address was delivered by Bishop Arthur J. Moore. Frank Lloyd Wright was unable to attend the dedication, as he was recovering from an automobile accident; he first viewed the finished building in May 1942. The distinctive "ship's prow pulpit" is shown in this photograph from the 1942 *Interlachen* yearbook. Fixed in place, it incorporated three levels of cast tapestry blocks at the base, was flanked by large planters, and had individual seats to the left and right rear of the speaker. The pulpit and many of the central first floor pews were destroyed when hurricane winds caused the collapse of the central tower on October 19, 1944. In its place was constructed a distinctly different, movable pulpit. (Courtesy Florida Southern College.)

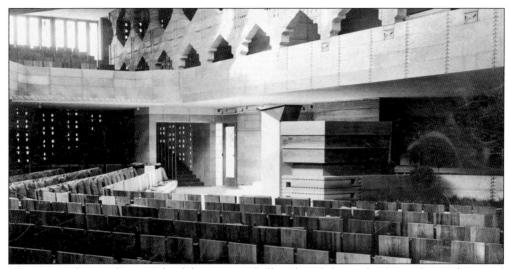

This extraordinary photograph of the Annie Pfeiffer Chapel shows the first pulpit and original Florida tidewater red cypress seats. These cushioned seats were built and assembled by students in woodworking and home economics classes. Each had two vertical backboards, and they were later joined in sections with wooden rails for stability. (Courtesy Special Collections, Lakeland Public Library, Lakeland, Florida.)

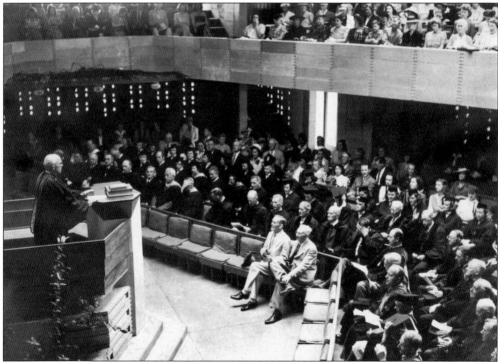

Dr. Ludd M. Spivey is seen here standing at the original pulpit addressing a formal gathering, including faculty in academic regalia. Dr. Spivey observed in May 1945 that the chapel developed hot spots as the sun passed through the skylight, causing interruptions to services as the congregation moved to cooler areas of the building. He pleaded with Frank Lloyd Wright to correct this problem in the rebuilt chapel. (Courtesy Florida Southern College.)

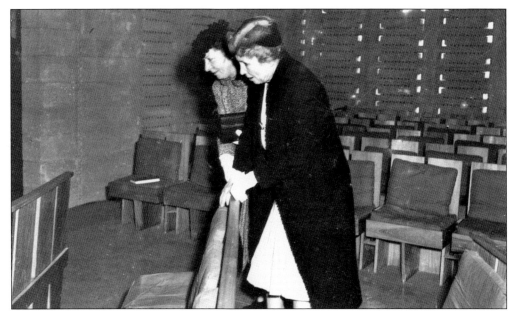

Helen Keller visited the Annie Pfeiffer Chapel during a Lakeland trip in February 1942, a guest of the Committee of 100 of Imperial Polk County. William Spivey, an accomplished pianist who later served on the college's music faculty, played for Keller and the Spivey family. Keller was photographed downstairs with Clara Spivey in one of the clearest extant images of the south transept pews. (Courtesy Florida Southern College.)

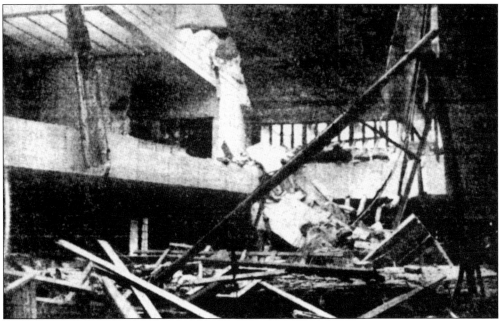

An unnamed hurricane with winds up to 75 mph struck Lakeland early on October 19, 1944. Local damage was widespread, including damage to the Annie Pfeiffer Chapel. *The Ledger* reported, "As part of the main structure collapsed, the huge skylight was shattered, and many of the seats in the auditorium below were damaged." Few photographs of the interior damage can be found today. (Courtesy N. F. Lavigne, *The Ledger*.)

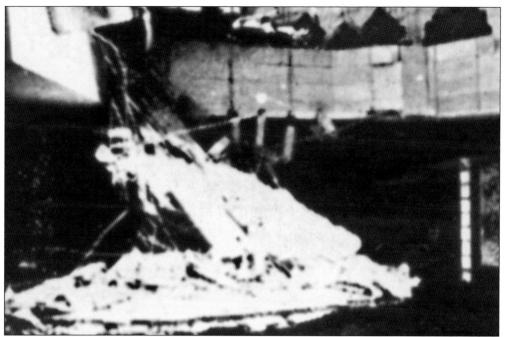

It took more than a year to clear the fully insured chapel and to make approximately $40,000 in repairs. Frank Lloyd Wright attributed the failure to poor workmanship. In 1948, Dr. Ludd M. Spivey was contacted by the American Institute of Architects concerning the collapse; Wright had been recommended for the AIA Gold Medal. Dr. Spivey deflected criticism from Wright and gave a glowing recommendation of the architect. (Courtesy Florida Southern College.)

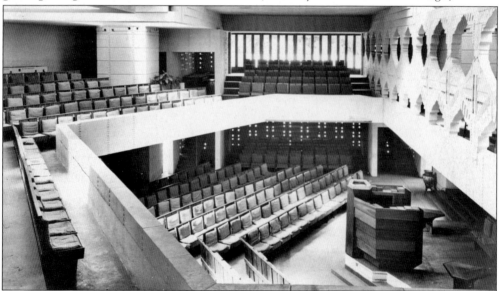

When the Annie Pfeiffer Chapel reopened after the hurricane, replacement Florida tidewater red cypress pews matched the originals, with 15-inch seats, and seat and back cushions 2 inches thick. The second pulpit, shown here without ornamental trim, was removable, at Dr. Ludd M. Spivey's insistence. The new skylight was manufactured by the Glendon Richards Company in Grand Rapids, Michigan. (Courtesy Florida Southern College.)

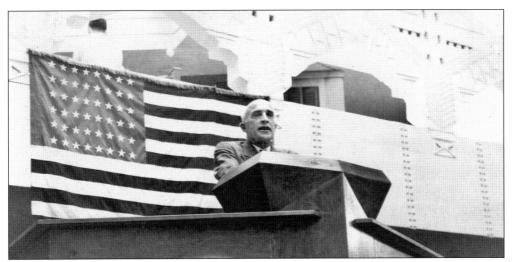

Dr. Ludd M. Spivey is seen against a patriotic backdrop in the chapel in this late 1940s photograph. It appears that he is standing behind the second pulpit, seen in the preceding photograph, to which ornamental trim had been added. (Courtesy Florida Southern College.)

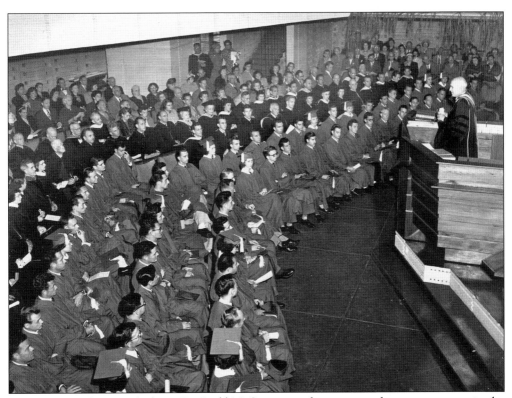

This pre-1952 photograph shows Dr. Ludd M. Spivey speaking at a graduation ceremony in the restored Annie Pfeiffer Chapel. The original-style pews are in place throughout. According to Lloyd G. Hendry, class of 1944, the repairs were made "using substantially more reinforcing steel than called for in the original specifications!" (Courtesy Harold Sanborn, Florida Southern College.)

Frank Lloyd Wright drew large crowds during his visits to campus. Here he pauses for a photograph during an evening address to the faculty and student body in the Annie Pfeiffer Chapel. The second, post-hurricane pulpit could be moved to allow the stage to be used for performances. Plants in pots have replaced the planters of the original design. (Courtesy Sanborn Photo Service, Florida Southern College.)

The weight of the building is borne by four 6-foot square hollow piers, one of which is visible to the right of the stairs. The balcony wall was four blocks tall when the chapel was constructed but was subsequently reduced to three blocks in height to allow better lines of sight to the repositioned pulpit. (Courtesy Florida Southern College.)

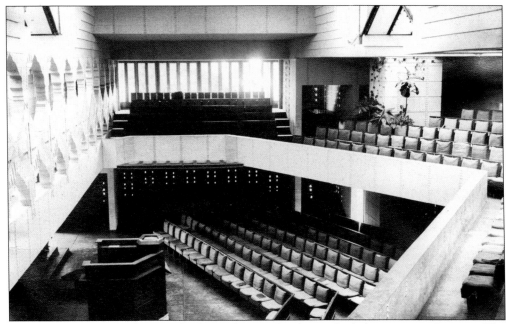

This photograph shows the second pulpit and original-style seats both downstairs and upstairs. The first floor is painted concrete, and the second floor was eventually tiled in red. There is currently red carpet throughout the first floor and on the staircases, and the second floor remains tiled. The basement contains small bathrooms and storage and mechanical systems rooms. (Courtesy Florida Southern College.)

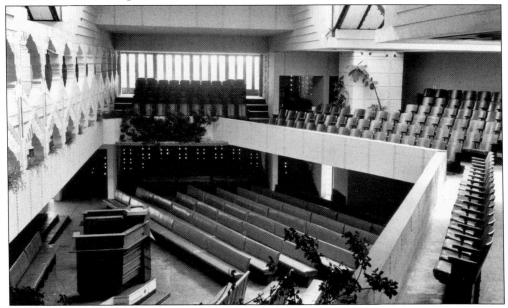

Second-generation chapel seating was a mix of red-covered bench seats downstairs and wooden-backed theater seats upstairs. An example of the bench seating is on display at the Child of the Sun Visitor Center in the former E. T. Roux Library. These benches were in the general style of seating used in the William H. Danforth Chapel and were constructed by students in industrial arts classes. (Courtesy Florida Southern College.)

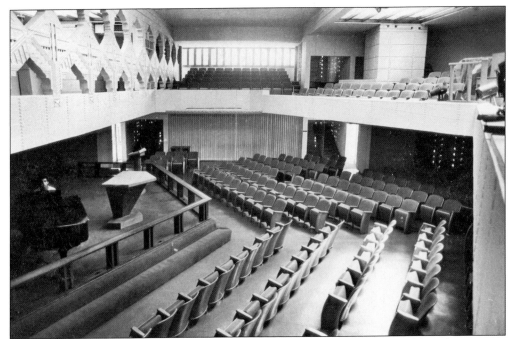

The current seating configuration is the third since 1941. The bench seats and first theater seats were replaced with used seats from Lakeland's Polk Theatre. There are 234 seats upstairs, 55 each in the north and south balconies, and 124 in the west balcony. Downstairs there are 276 seats, for a total of 510. Transept seating areas were enclosed to form exhibit rooms after the Branscomb Memorial Auditorium opened in 1964. (Courtesy Florida Southern College.)

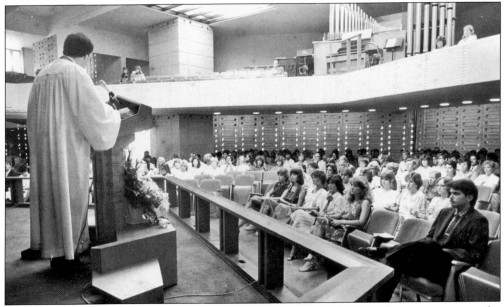

This photograph, looking toward the balcony and repositioned organ, shows a service in the Annie Pfeiffer Chapel. The organ originally had been positioned behind the decorative, concrete screen above the rostrum, and it subsequently was put back there. The rail bordering the rostrum is removable. (Courtesy Brad Beck, Florida Southern College.)

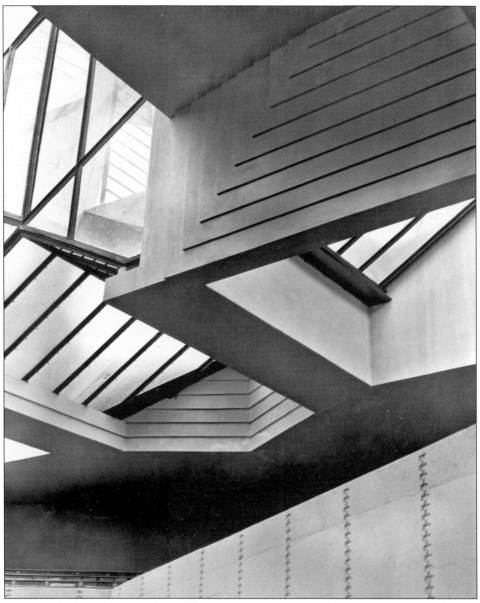

This unusual view of the Annie Pfeiffer Chapel skylights was taken before the October 1944 hurricane. It shows one of the four side skylights without inset-framed covers. Soon after construction, all four were covered from beneath to disguise lighting fixtures. The first pews are visible above the balcony wall. The Annie Pfeiffer Chapel was used for many academic gatherings and programs until January 1964, when the Nils Schweizer-designed Branscomb Memorial Auditorium was constructed overlooking Lake Hollingsworth. Frank Lloyd Wright's unique architecture has also served as a backdrop for nonacademic productions. Many scenes for two episodes of the television series *seaQuest DSV* were filmed at Florida Southern College in 1994. Scenes were filmed in the Ordway Industrial Arts Building and in the Annie Pfeiffer Chapel. Both buildings are clearly recognizable, although sets and props altered the look of both during production. Other local scenes were filmed in the college's Hindu Garden of Meditation, downtown around Munn Park, and at Joker Marchant Stadium. (Courtesy Florida Southern College.)

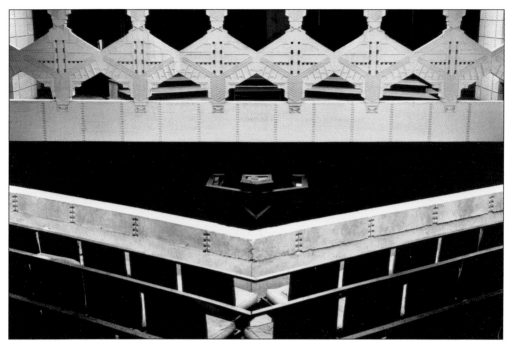

Local lore suggests that the choir screen was installed upside-down, but it was installed as designed. Choir stairs, seen in this post-1944 photograph, helped performers see the audience. Former student and vocalist Eleanor Searle Whitney aspired in the mid-1940s to fund a Frank Lloyd Wright-designed music building. Neither she nor Wright would compromise their functional and design ideals, and the building was not constructed. (Courtesy Florida Southern College.)

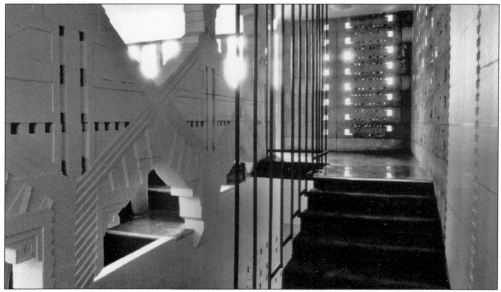

The staircases located in each of the four corners of the chapel have 4.5-inch risers and 12-inch treads. They are supported by hung "rail rods." Staircases of similar design are found in the Polk County Science Building. This photograph shows the corner at the top of the northeast staircase and the back of the choir loft screen. Sunlight streams through the jewel-like glass inserts. (Courtesy Florida Southern College.)

Two

SEMINAR BUILDINGS AND THE ESPLANADE

The seminar buildings were constructed in 1941 as three distinct classroom buildings. They were named in honor of Cora Carter, Charles W. Hawkins, and Isabel Walbridge. Carter was a retired schoolteacher, Hawkins was professor of ancient languages from 1935 to 1957, and Walbridge served as dormitory hostess for many years. The buildings were reconfigured in 1958 and 1959 to house college business offices. (Courtesy Florida Southern College.)

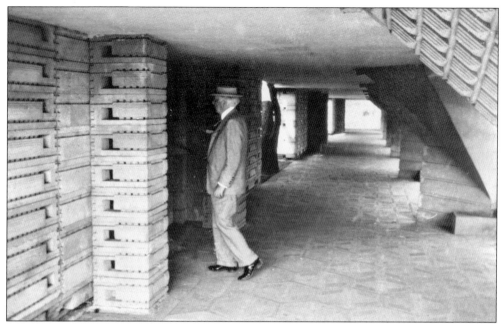

Frank Lloyd Wright is seen entering the Isabel Walbridge Seminar Building in May 1949. Each building featured two small offices and one large classroom, and courtyards separated the buildings. The southeast corner office provides a spectacular example of Wright's jewel-box effect, as light plays through glass inserts in the blocks. Hexagonal pavers under the Esplanade were inscribed with donors' names. (Courtesy Donna Stoddard, Florida Southern College.)

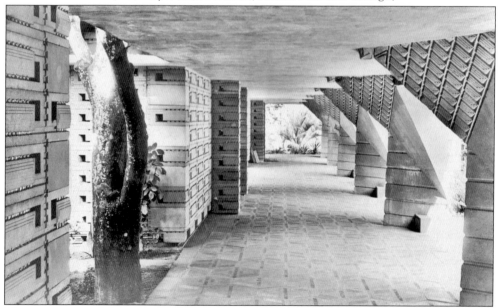

This view eastward shows a portion of each of the seminar buildings. Access was from the south, where a dirt car path extended in front of the buildings. The student business office is now located where the tree in the closest 18-foot-wide courtyard stood. In December 1941, this 260-foot length was the first Esplanade roof poured, requiring 47 cubic yards of concrete. (Courtesy Florida Southern College.)

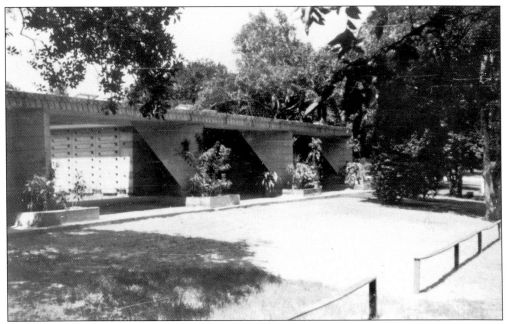

Dr. Ludd M. Spivey's office was in the large room in the north end of the Cora Carter Seminar Building. Frank Lloyd Wright designed these three classroom buildings with skylights, and in this c. 1942 view, the open skylights are visible above the Esplanade top. The Esplanade ceiling height here varies from 6 feet, 6 inches, to the standard 6 feet, 9 inches. (Courtesy William M. Scruggs, class of 1943, Florida Southern College.)

This 1948 Atlantic Coast Line Railroad photograph shows the new J. Edgar Wall Waterdome and the seminar buildings. Pipes leading to the Waterdome are visible at far left. In the seminar buildings, one can see differences in colors of the concrete blocks and variations in the use and placement of decorative and plain blocks. This is the result of experiments to determine the most appealing colors and patterns. (Courtesy Florida Southern College.)

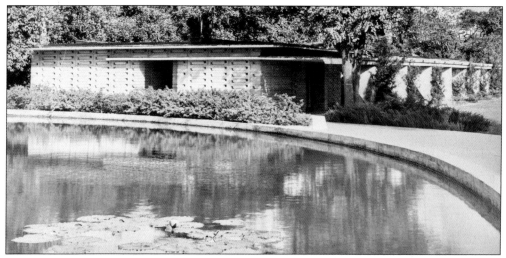

This image of the Waterdome and seminar buildings likely dates from the late 1940s. The Esplanade ended at the eastern-most building but eventually was continued when other buildings were constructed. Two columns in front of the Cora Carter Seminar Building feature inset decorative plaques, including one dedicated to Jacksonville judge "C. B. Peeler" and another to the "Senior Class Summer 1941." Frank Lloyd Wright did not approve these metal plaques. (Courtesy Florida Southern College.)

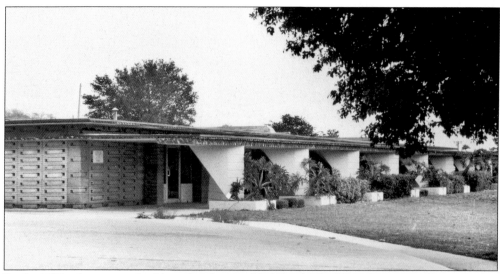

By the 1970s, the seminar buildings barely resembled Frank Lloyd Wright's original vision. After the buildings were reconfigured in the late 1950s, a cinder-block addition was constructed in 1964 and 1965 behind the Isabel Walbridge Seminar Building, and the entire complex was renamed the L. A. Raulerson Building. The cornerstone for each seminar building remains visible close to the ground on the southeast corner, facing south. (Courtesy Florida Southern College.)

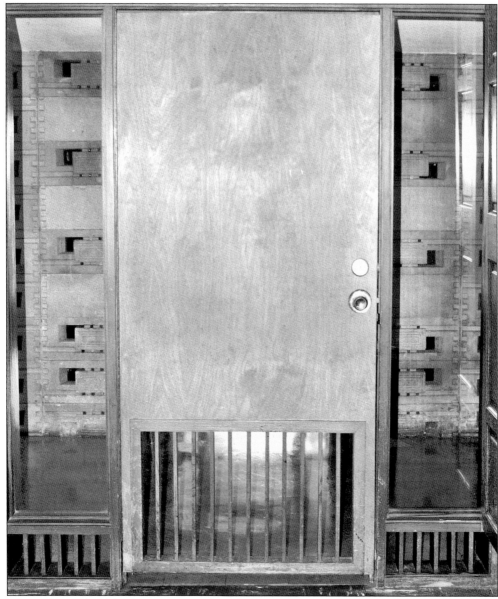

This is the inside of the door to Dr. Ludd M. Spivey's office in the Cora Carter Seminar Building. The ventilation grill in the door and the bottom of the sidelights offered a similar air circulation function as a transom window. Frank Lloyd Wright was well-known for his dislike of air-conditioning, and his solution was to find ways for air to circulate through his buildings, but the rooms in these buildings were too hot to feel comfortable in the Florida heat. Wright then devised an alternate cooling method. Hattie Schindler Horwitz, who in 1976 wrote a University of Miami master's thesis on Florida Southern College's Child of the Sun campus collection, reported that Wright "had the sides of the [seminar buildings'] roofs built up, covered with roofing paper, added rocks on top of that, then arranged to have water run on the roofs to cool the buildings. This primitive air-conditioning plan was fairly effective, except that it leaked and, ultimately, had to be abandoned." Unfortunately, Dr. Spivey's office has been split into two separate rooms. (Courtesy Nora E. Galbraith.)

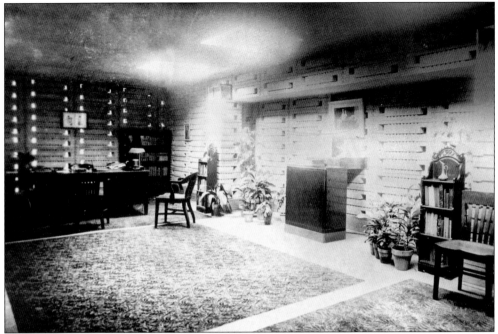

Dr. Ludd M. Spivey's office was described in the 1943 *Interlachen* yearbook as follows: "Housed in one of the new seminars, approached by freshmen with fear and trembling, and known by seniors as the source of dependable advice from a real friend." The room was softly lit by colored-glass inserts in the perforated tapestry block and had three skylights for ventilation and additional light. (Courtesy Florida Southern College.)

The low-slung mechanical room extending north from the Cora Carter Seminar Building contained the Waterdome pump above a 1,100-foot-deep well. The 80-foot-long room is 15 feet wide, is constructed of solid tapestry block, and has metal grill–covered windows and an attractive copper-lined roof segment on the west side. In 2007, the floor was dropped 2 feet and new Waterdome equipment was installed. (Courtesy Nora E. Galbraith.)

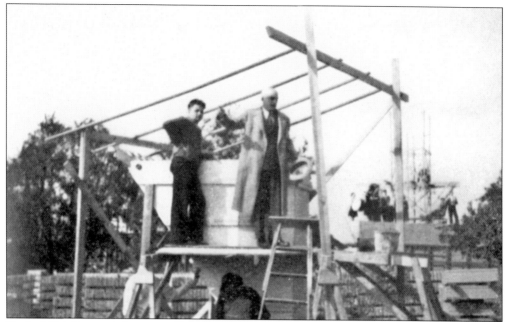

Dr. Ludd M. Spivey dedicates an Esplanade column in this photograph from the 1940 *Interlachen* yearbook. The Annie Pfeiffer Chapel was taking shape in the distance, and stacks of cast blocks are visible. Most of the planters are inscribed on two sides with donor names, and some family groups are recognizable. The largest is the Lykes family, which gave many of the columns east of the seminar buildings. (Courtesy Florida Southern College.)

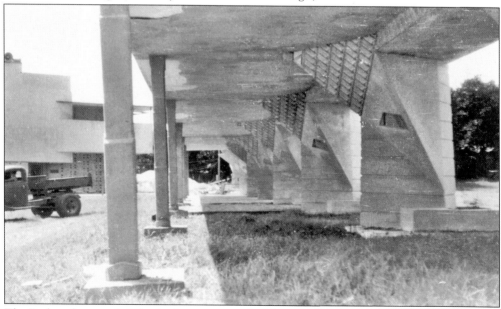

The Esplanade extends 1.5 miles between most buildings and was constructed between 1940 and 1958, with one small section near the Danforth Chapel completed in 1969. This first section—with secondary support posts opposite the columns—was under construction by March 1941 and covered a walkway later paved with decorative hexagonal blocks. Either the roof or this entire section was replaced. (Courtesy William M. Scruggs, class of 1943, Florida Southern College.)

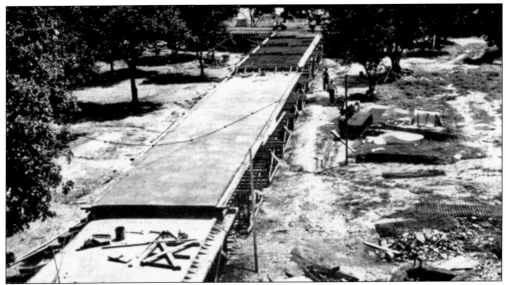

The Esplanade was constructed in sections as the building of the campus progressed. This section extends from near the Annie Pfeiffer Chapel north toward the seminar buildings and was completed in 1949. Nils Schweizer wrote, "The esplanades not only link the buildings together, but weave in and out of the buildings themselves. Further, most all of the elements of scale, dimension, and materials are embodied in the Esplanade." (Courtesy Florida Southern College.)

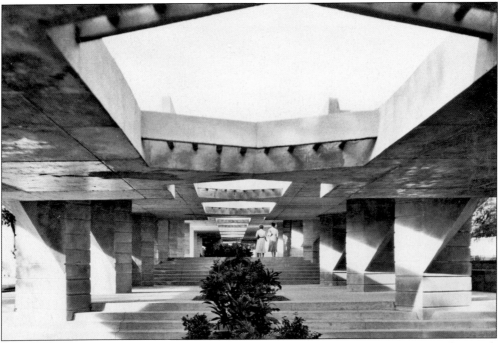

The Esplanade between the library and administration buildings is nearly 36 feet wide. Frank Lloyd Wright wrote in *An Autobiography* that he used his scale when designing buildings. "Taking a human being for my scale, I brought the whole house down in height to fit a normal one—ergo, 5 feet, 8.5 inches tall, say. This is my height . . . [b]elieving in no other scale than the human being." (Courtesy Florida Southern College.)

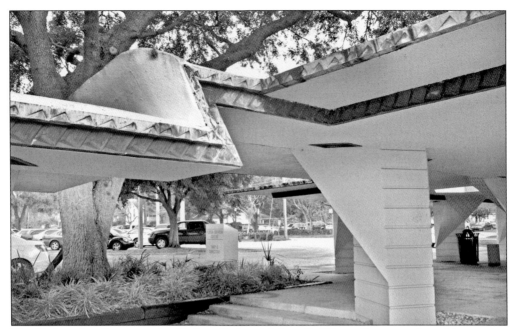

The Esplanade adjacent to the Ordway Industrial Arts Building offers a number of interesting intersections and perspectives, as seen near the northwest corner. Decorative copper trim along the edges of the Esplanade was attached in stamped sheets, typically in widths up to 6 inches tall, and with 2- or 4-foot exposed lengths. (Courtesy Nora E. Galbraith.)

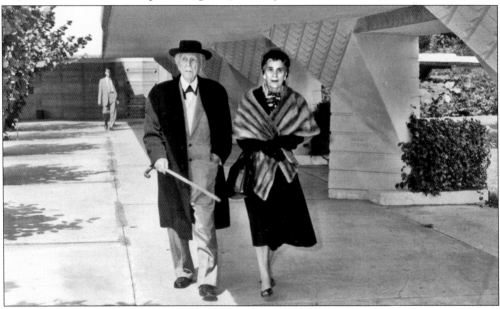

Frank Lloyd Wright and Olgivanna Lloyd Wright walk under the Esplanade from the E. T. Roux Library toward the Annie Pfeiffer Chapel on their way to inspect the Polk County Science Building in March 1957. The May 23, 1958, student newspaper published a photograph of 6-foot, 7-inch freshman basketball player Bob Hopkins walking alongside the Esplanade north of the Polk County Science Building, while his 5-foot, 2-inch girlfriend Patricia Laden walked underneath. (Courtesy Florida Southern College.)

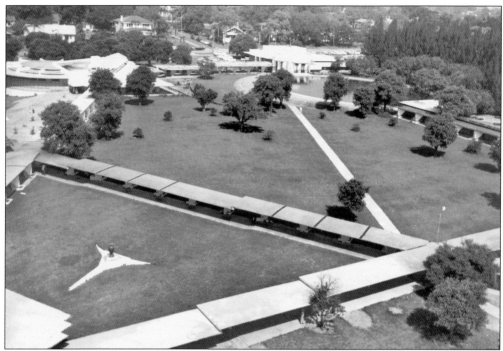

Observant visitors will notice two peculiar notches in the Esplanade roofs where the structures were built around then-existing trees. One is east of the seminar buildings closest to the "James M. Lykes" column. The second is north of the greenhouse, along the Esplanade northeast from the Annie Pfeiffer Chapel. It is closest to the column dedicated to "Mr. & Mrs. A B Carr." (Courtesy Florida Southern College.)

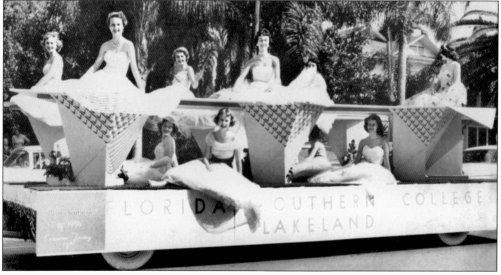

Based on the Esplanade, this whimsical 1956 homecoming parade float carried the candidates for Miss Southern. This was followed in 1959 by a homecoming float that resembled the Polk County Science Building. Several years after the first Esplanade sections were completed, a homecoming parade of small floats was moved along the top of the Esplanade—enough to make both modern preservationists and risk managers cringe. (Courtesy Florida Southern College.)

Three

E. T. ROUX LIBRARY

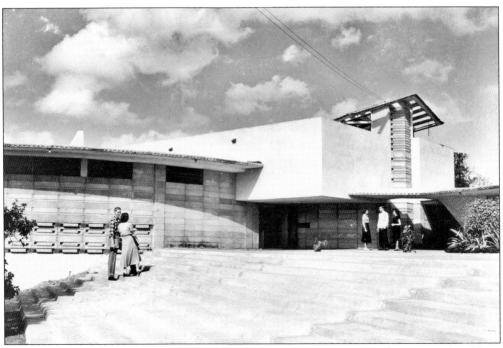

The E. T. Roux Library features a nearly circular reading room intersected by an irregular oblong section running across the northeast quadrant of the circle at 30 degrees from northwest to southeast. This two-story-plus-basement section contained book stacks and offices. The ground floor plan offers an interesting general comparison with that of the famous, sixth-century church of San Vitale at Ravenna, Italy, which Frank Lloyd Wright must have known. (Courtesy Sanborn Photo Service, Florida Southern College.)

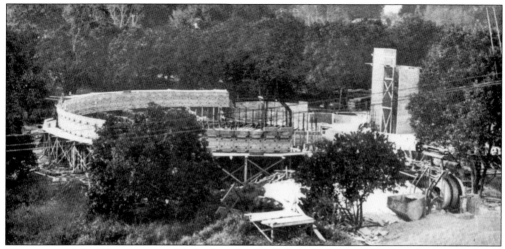

This view of the library was published in the 1943 *Interlachen* yearbook. The building was constructed between 1941 and 1945 at a cost of $120,000 largely using student labor under the supervision of Robert D. Wehr and in spite of World War II manpower and materials shortages. (Courtesy Florida Southern College.)

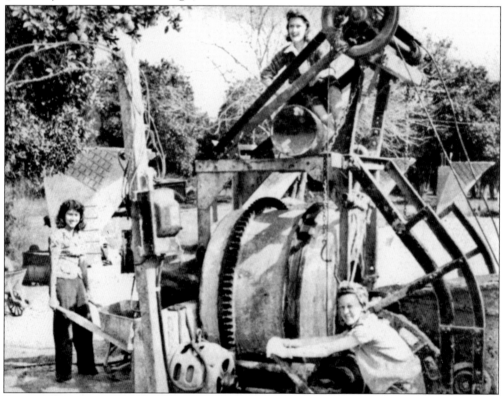

Every student was involved in some manner in building the library; here coeds mix cement for the project. The Esplanade columns in the background extended east toward the Annie Pfeiffer Chapel. The building was made possible through the generosity of lumberman, banker, and hotel owner Edwin Timanus Roux, a longtime trustee who had helped facilitate the college's move to Lakeland in 1922. (Courtesy Florida Southern College.)

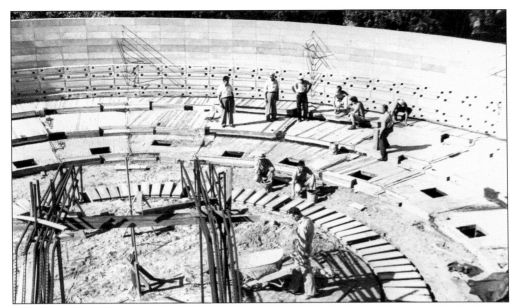

When this photograph was taken, the outside walls had been completed up to window level, and the stair-stepped floor of the reading room had been poured. Workers were preparing blocks for additional construction. Nils Schweizer, who was later Frank Lloyd Wright's on-site supervisor, wrote, "Students learned to set forms, cut steel, weld, pour and finish concrete, set blocks, and a myriad of related tasks." (Courtesy Florida Southern College.)

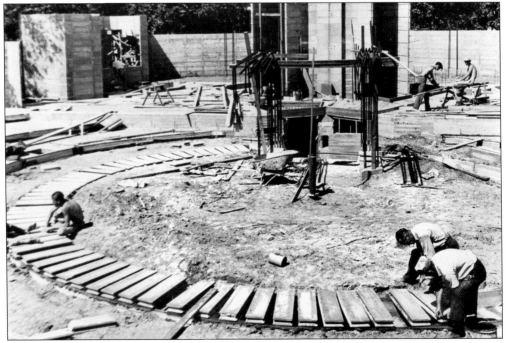

Supports for the central reading room columns are visible, as is the two-story fireplace core and flanking stairwell to the north. According to Prof. Donna Stoddard, "The student workers molded 14,000 blocks by special patterns and laid more than 4,600 of them." (Courtesy Florida Southern College.)

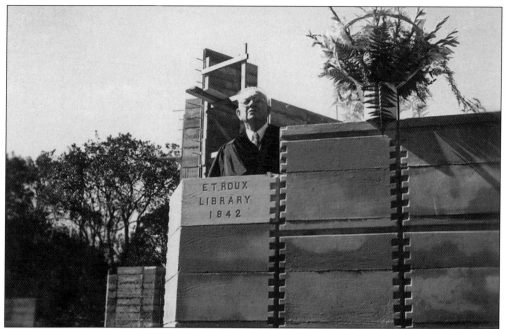

Ground breaking for the library took place on April 23, 1941, and this photograph shows trustee Edwin Timanus Roux at the 1942 cornerstone ceremony. The dedication ceremony was on March 17, 1945. The large portrait of Roux that hung for years in the library is now displayed in the L. A. Raulerson Building. (Courtesy Florida Southern College.)

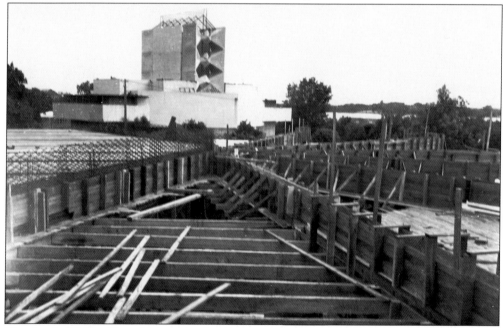

The Annie Pfeiffer Chapel is seen in the distance, past forms used to pour the concrete roof of the E. T. Roux Library. Hattie Horwitz wrote, "The building violates all conventional lines of architecture as it seems literally to rise out of the ground on one side, while the other side rests squarely on the plaza." (Courtesy Florida Southern College.)

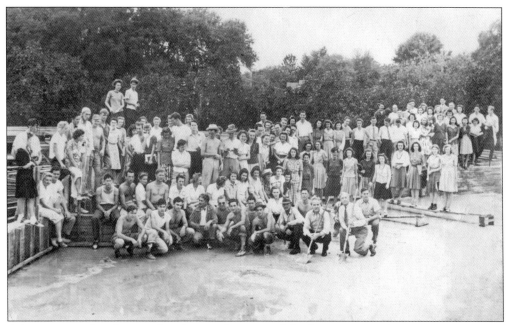

A large group of students and student workers paused for the camera on the construction site of the library in 1944. *The Southern* often published a plea for construction assistance, usually when concrete was to be poured. This might have been in May, when work commenced on the third floor. (Courtesy Florida Southern College.)

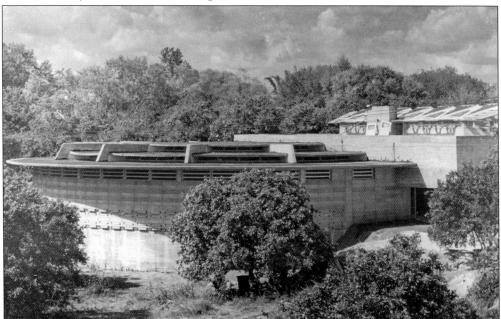

In this photograph, as the E. T. Roux Library was nearing completion, two small doors are visible on the roof, awaiting installation. The roof was accessible through these doors from atop a dual staircase on the east and west sides of the central chimney. The sidewalk and plaza leading to the Annie Pfeiffer Chapel had not been poured, and the stairs leading south from the east entrance had not been built. (Courtesy Florida Southern College.)

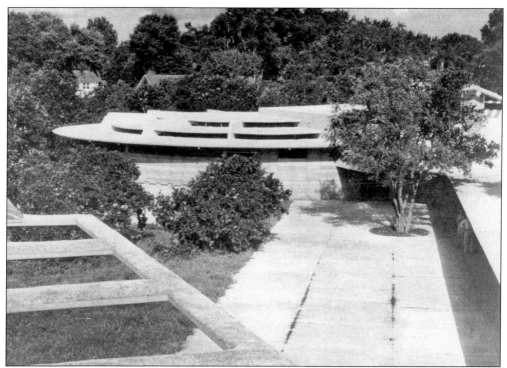

A corner of the Annie Pfeiffer Chapel roof is visible in this photograph of the newly completed library. The original 10-foot tree circle near the entrance may be seen in the sidewalk. This was filled, and a grid of small square planters was installed along the length of the plaza. The plaza has variously been planted with sea grapes and crape myrtles. (Courtesy Florida Southern College.)

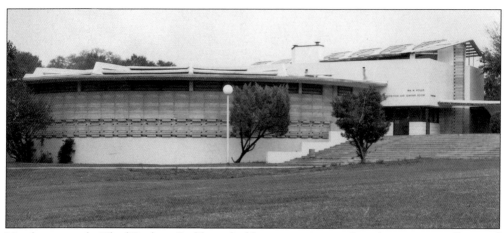

Now known as the Thad Buckner Building, the library was converted to administrative offices and meeting space in 1968 and 1969, when the new Roux Library was built north of the reconfigured Waterdome. The former book stack floors were closed off and divided into offices. The reading room, renamed the William E. Hollis Room, became a venue for meetings and conferences. (Courtesy Florida Southern College.)

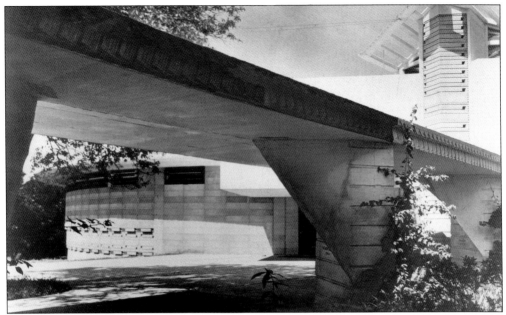

The east entrance is seen in this image from the 1950s. In 1985, Prof. Thomas B. Mack remarked that Frank Lloyd Wright "made it most evident that the architecture was primary and that plants around his buildings were not necessary. I suppose that is why we find huge masses of concrete walk poured right up to and around the foundation of the buildings." (Courtesy Florida Southern College.)

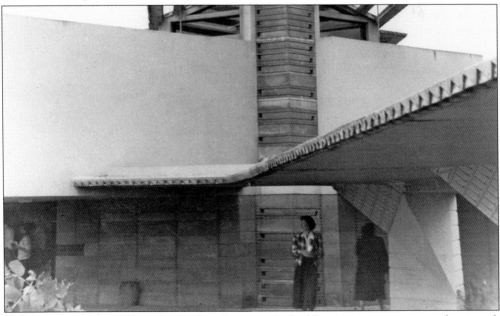

In this image, the area where the Esplanade meets the building's main entrance can be viewed. Here the cutouts that Frank Lloyd Wright loved to design can be seen in the overhanging eaves. Note the repeated use of triangular shapes in this building created with many geometric shapes. The playfully sophisticated use of geometry is at the heart of Wright's designs for Florida Southern College. (Courtesy Florida Southern College.)

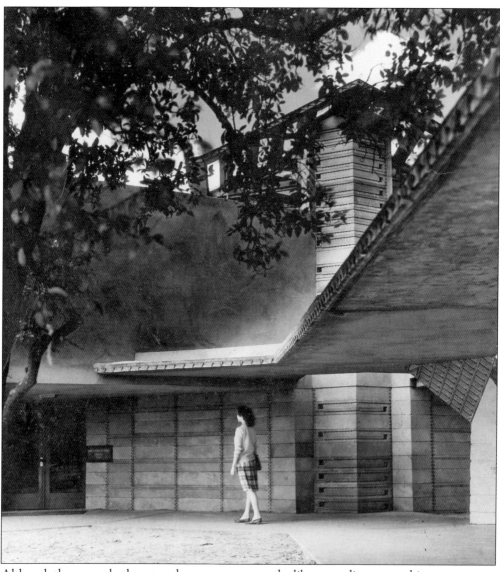

Although there were both east and west entrances to the library reading room, this east entrance became the de facto main entrance due to its proximity to dormitories and classroom buildings. A portion of the original cornerstone and block wall has been covered, but the cornerstone remains visible adjacent to this entrance: "E. T. Roux/ Library/ 1942." For a time, a second plaque—seen in this photograph—marked the same entrance, for reasons unknown. The second plaque is on exhibit in the college archives. The matching west side entrance was obscured when, in 1956, a 900-square-foot office addition was created beneath the Esplanade leading north from the building. This became the technical services department, where books were cataloged and processed. Longtime art professor Donna Stoddard wrote, "One outside corner of the E. T. Roux Library suggests a dense forest the way the Esplanade columns are grouped with light filtering through a beautifully patterned opening to the sky." (Courtesy Florida Southern College.)

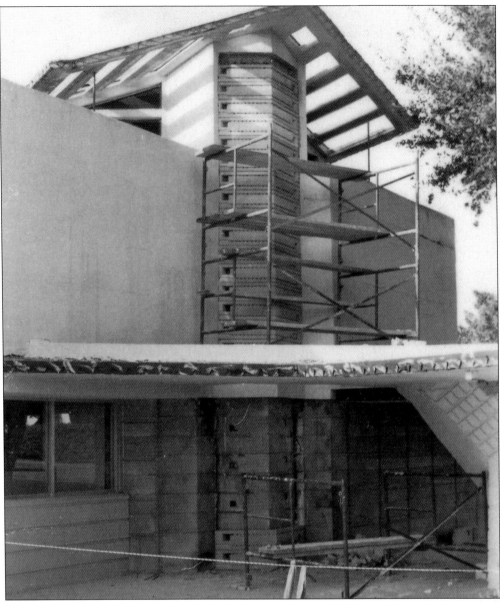

Major campus renovation projects were undertaken during the summer of 1981. Extensive block replacements were made on the west facade of the Annie Pfeiffer Chapel and the east end of the former E. T. Roux Library. An Esplanade column between those two buildings was reconstructed. Missing glass inserts throughout the Annie Pfeiffer Chapel were replaced, and the rooftop trellis was rust proofed. The roofs of the William H. Danforth Chapel and the former E. T. Roux Library were resealed, and the decorative "light needle" at the north end of the administration buildings was replaced. The Esplanade column that had to be replaced was recast under the direction of Nils Schweizer using fiberglass molds made from another column. The replacement column is most easily distinguished by a 6-inch protruding triangular shape where the column meets the roof; no adjacent columns share this feature. The decorative features of the replacement are not as precisely defined as on other columns, but to a casual observer, this is not obtrusive. (Courtesy Florida Southern College.)

The 1981 repair work at the east end of the former E. T. Roux Library revealed period graffiti between the interior and exterior blocks. Structurally, the buildings remained sound, but deterioration extended to the steel reinforcement rods buried in the mortar. Replacements were made for some of the embedded, colored-glass pieces that had fallen out or had been removed by souvenir hunters. (Courtesy Florida Southern College.)

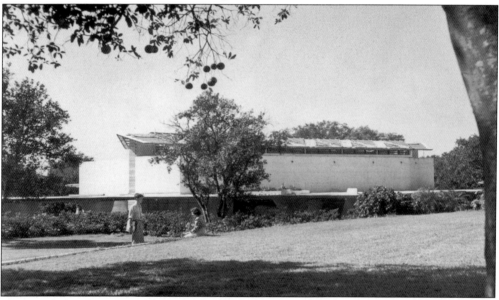

The rounded wall north of the library is 165 feet long. In a letter to Dr. Ludd M. Spivey in 1938, Frank Lloyd Wright described his vision for the buildings: "I can assure you that we shall have a college unequaled. Each building is individual in character—practical in effect—yet contributing its share to an occult symmetry—delightfully informal and easy as a whole." (Courtesy Harold Sanborn, Florida Southern College.)

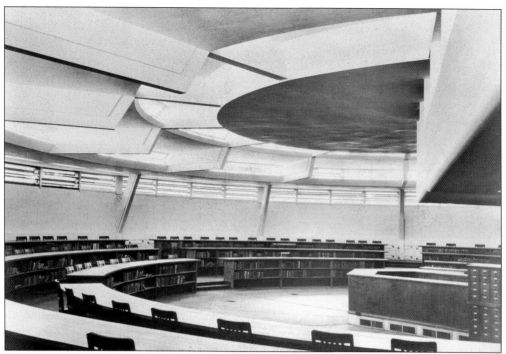

The circular reading room is 90 feet in diameter and about 15 feet tall. Note the clerestory windows all around the room that admit light and ventilation. Frank Lloyd Wright designed wooden desks for the three tiered floor levels in the room. The outer sides of the massive desks contained built-in bookcases for the reference collection. (Courtesy Florida Southern College.)

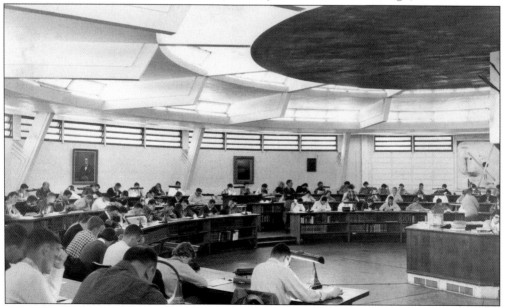

Since the interior of the reading room was rather dark at night, the library staff kept reading lamps on the tables. However, when it was known that Frank Lloyd Wright would be coming for a visit to the campus, the lamps were removed, as they were not part of his design. The portrait at far left is of Edwin T. Roux. (Courtesy Florida Southern College.)

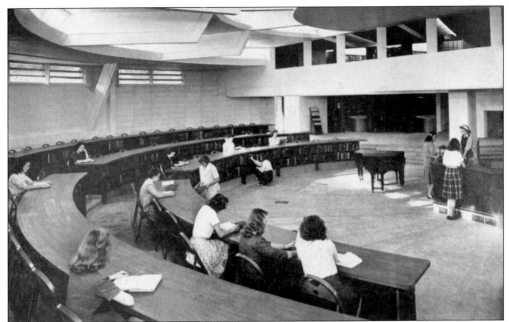

This is one of two paired images of the then-recently completed library published in the 1947 *Interlachen* yearbook. The circulation desk, on a slight elevation, was situated in the center of the room. From here the librarian could see most of the room and a portion of the book stacks. The library was used for musical performances while chapel repairs were under way. (Courtesy Florida Southern College.)

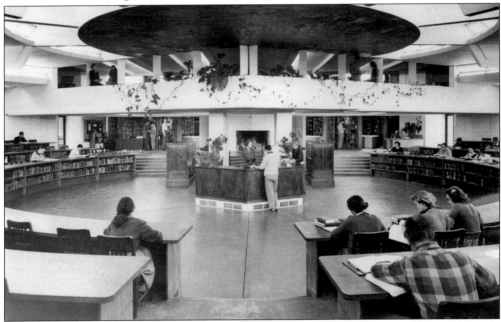

This image from the early 1950s was used in many period viewbooks and in the *Interlachen* yearbook. Frank Lloyd Wright wished to convey a garden-like quality in all of the campus buildings he designed. Although the growing conditions were difficult, greenery overhung the reading room. (Courtesy Florida Southern College.)

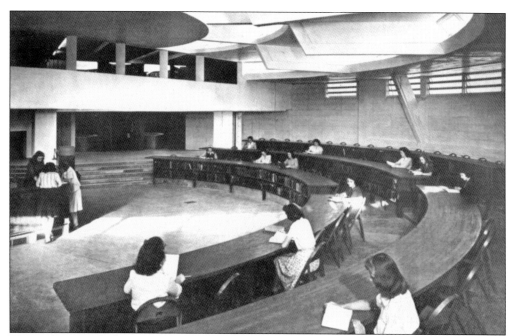

This is the second of two paired images of the new library in the 1947 *Interlachen* yearbook. Steps led into the reading room from the book stacks and from each desk tier. These stepped areas were inaccessible to book carts. The clerestory windows presented another challenge. Dr. Ludd M. Spivey wrote to Frank Lloyd Wright in July 1945 complaining that it was cumbersome to open every window each morning. (Courtesy Florida Southern College.)

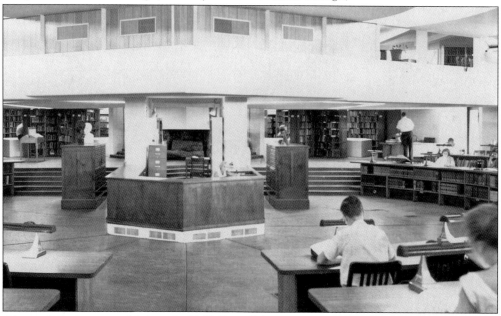

Air-conditioning was added to the E. T. Roux Library prior to construction of the new Roux Library, north of the J. Edgar Wall Waterdome. The air-conditioning ducts were installed along the balcony above the circulation desk through wood paneling, dramatically altering the space. (Courtesy Florida Southern College.)

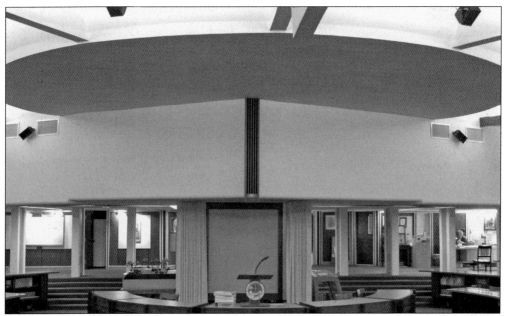

Reconfigured by the 1960s remodeling, the reading room interior is much less open. The balcony that overlooked the room has been enclosed. The fireplace is obscured in this view by a screen behind the podium. The stairs that went up to the top floor have been removed and some of the space made into storage closets. The room is compromised but still unique. (Courtesy Nora E. Galbraith.)

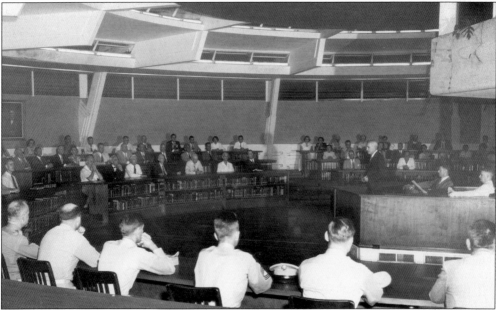

Dr. Ludd M. Spivey addressed the faculty during an unusual nighttime gathering in the reading room in the 1950s. This photograph illustrates how little light was available after sunset. Another problem the staff encountered during daylight hours was hot spots created by the sun-filled light wells. Frank Lloyd Wright did not take into account the heat of the Florida climate. (Courtesy Florida Southern College.)

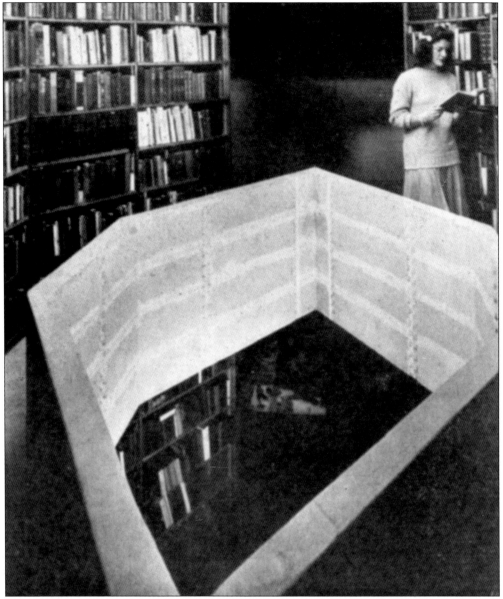

This photograph from the 1947 *Interlachen* yearbook showing top-floor book stacks and a light well hints at the challenges they presented. Aesthetically, the light wells were important to Frank Lloyd Wright's garden-inspired design, but book stacks could not run straight throughout the building; they had to wrap around the wells, creating underutilized spaces. The skylights were inclined to leak when it rained, requiring the library staff to cover the books in plastic. The top floor light wells still exist, but the wells between the middle floor and the basement were removed when the building was reconfigured. In an essay Wright wrote for the 1951 yearbook, he offered these words to the students: "Your college buildings have been in a continuous state of growth. Their outdoor garden character is an expression of Florida at its best. Study these buildings because unless you do know something about the kind of building we call Organic Architecture, you can't really know very much about anything else worth knowing." (Courtesy Florida Southern College.)

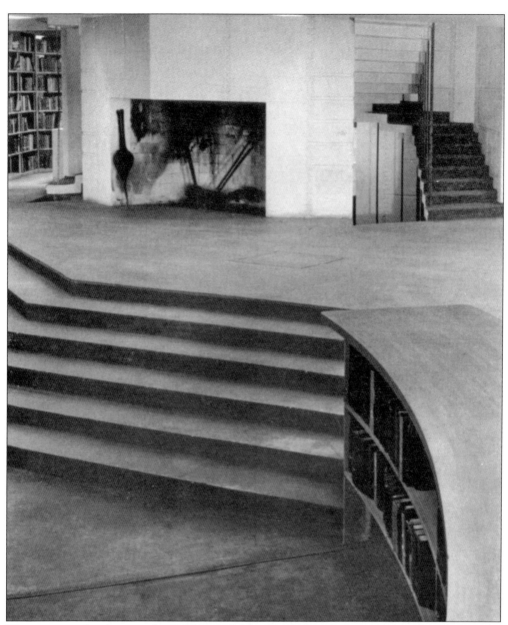

There are two fireplaces in the E. T. Roux Library, including this one visible from the circular reading room. The second is on the top floor of the building, served by the same chimney. This fireplace is large, impressive, and centered in the space. There were originally two staircases flanking the fireplace that went up to the stacks and down to the basement. They were similar in structure and appearance to the four in the Annie Pfeiffer Chapel. The staircases were reconfigured along with the rest of the building in 1968 and 1969, and now there is just one descending staircase to the right of the fireplace, which leads to bathrooms and storage space. In a 1985 interview, librarian Louise W. Eastwood, who spent 17 years of her 45-year library career working in this library, related that "Mr. Wright is known for his fireplaces. We had a beautiful fireplace. We had one fire in that fireplace the whole time that I can remember." (Courtesy Florida Southern College.)

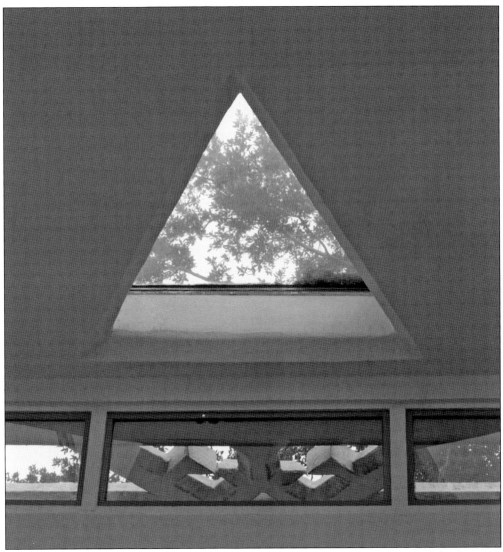

The current skylights and side windows are shown in this view from the top floor of the former E. T. Roux Library. The intricate decorative design of the exterior roofline may be seen. The skylights feature variations of triangular shapes, and are framed in red, a signature accent color Frank Lloyd Wright used throughout the campus. The color palette coincidentally echoes the school colors of red and white. An examination of the Child of the Sun campus collection focusing on the then-new administration buildings was published in the September 1952 *Architectural Forum*, which occasionally published other articles about the project. In an essay about the campus, Wright had this to say: "[I]f you would honestly try to understand these Florida Southern College buildings and would really know what they are all about . . . something important to our country's future as a democratic nation will transpire." (Courtesy Nora E. Galbraith.)

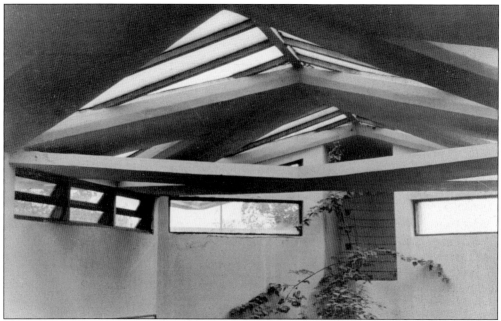

This photograph shows the library's top floor, facing east, and was taken from a landing on the stairs leading to the roof. The sunlight streaming in from the skylights was meant to light all the way to the basement, but at night, there wasn't enough light to read book titles on the shelves. (Courtesy Saul Rosenblum, Florida Southern College.)

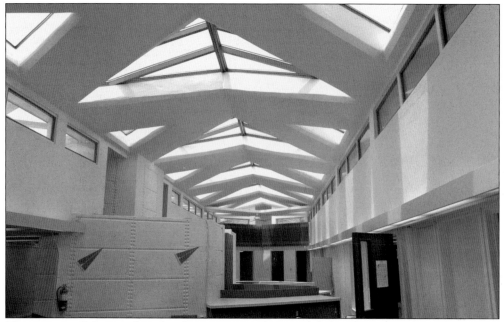

The interior of the top floor has been extensively remodeled and converted to office space. Skylights similar in design to Frank Lloyd Wright's provide bountiful light, although through darker panes than the originals. This view faces the west end of the building and shows, on the left, the dominant former staircase well that provided roof access from the east and west sides of the chimney. (Courtesy Wayne Koehler.)

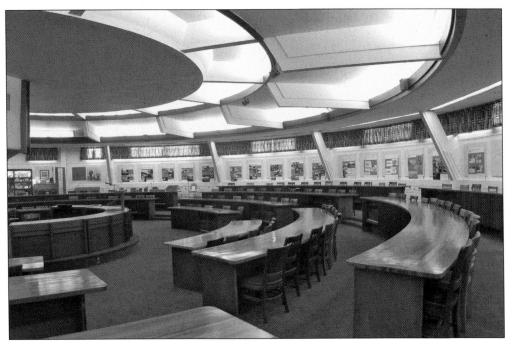

The reading room has continued to be changed. The clerestory windows that Dr. Ludd M. Spivey complained about have been sealed and curtained. The Child of the Sun Visitor Center was opened in 1992. Displays of buildings designed by Frank Lloyd Wright's apprentices, part of an exhibition in the college's Melvin Art Gallery, have been hung on the circular wall, along with drawings and plans done by Wright. (Courtesy William Carpenter.)

A reproduction tapestry block with openings for colored glass inserts and an original block form are displayed in the Child of the Sun Visitor Center. Student workers made thousands of blocks in various shapes for the Annie Pfeiffer Chapel, the seminar buildings, and the E. T. Roux Library. They were also used in other structures. Frank Lloyd Wright predicted his buildings "will be standing a thousand years into the future." (Courtesy Nora E. Galbraith.)

The Child of the Sun Visitor Center's displays include an original library chair with a turquoise blue cushion. Raleigh Bailey, class of 1965, was "intrigued and wounded by the concrete, cantilevered-covered walkways that connected the buildings. My wounds came from banging my head while walking too close to the diagonal pillars. The low roofs on the walkways and buildings served as a challenge for young people who liked to climb. During that era of fun-loving road trips and kidnapping amongst fraternity groups, roofs served as hiding spots for ambushes targeting fraternity brothers returning from late-night lab work. As we matured, however, we moved away from such lower classmen's activities and began to explore more lofty callings. The L. A. Raulerson Building, east of the reflection pool, had a concrete, latticework wall on the rear side that reached to the roof. An enterprising couple could climb that wall fairly easily to the roof where there awaited a secluded place for courting, with an accompanying lofty view of the campus. The Frank Lloyd Wright buildings provided a creative link between structure and function." (Courtesy Nora E. Galbraith.)

Four

ADMINISTRATION BUILDINGS AND THE WATERDOME

The Emile E. Watson and Benjamin Fine Administration Buildings were constructed between 1946 and 1948 at a cost of $200,000. The buildings are often perceived as one structure, but they are distinctly separate and connected by the Esplanade. The J. Edgar Wall Waterdome was a spectacular circular pool 160 feet in diameter constructed during 1947 and 1948 at a cost of $15,000. (Courtesy Florida Southern College.)

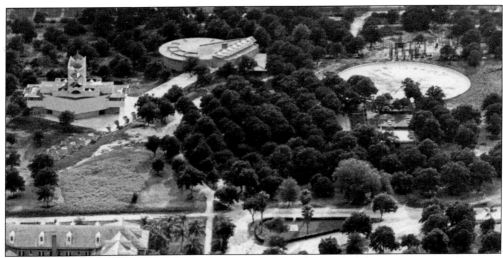

This 1947 westward-facing aerial view shows the completed Waterdome basin and the beginning of administration building construction. Of additional interest are the thick trees south of the seminar buildings and the roofless Esplanade columns east of the Annie Pfeiffer Chapel, where formerly there had been a covered Esplanade section. (Courtesy Sanborn Photo Service, Florida Southern College.)

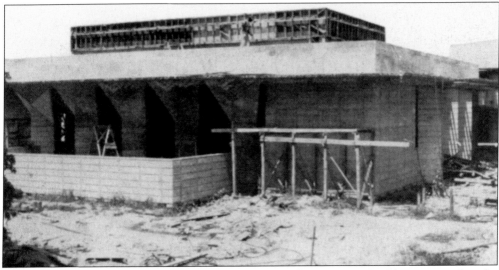

This construction photograph of the Emile E. Watson Administration Building appeared in the 1950 *Interlachen* yearbook. Dr. Ludd M. Spivey sent specific instructions to Frank Lloyd Wright regarding this building: "Three rooms for president . . . room for 24 directors to meet around table . . . two rooms for dean of college . . . special room for special occasions. Total of 14 rooms . . . See there are ample toilets . . . Please no basement." (Courtesy Florida Southern College.)

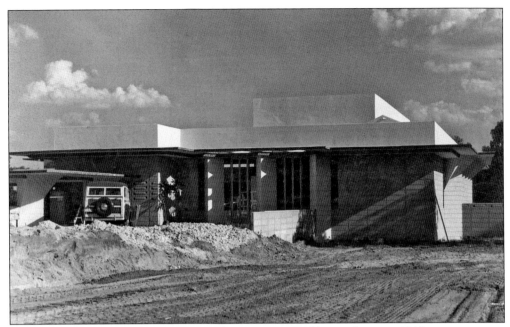

The north side of the Emile E. Watson Administration Building is shown in 1948 as construction was nearly completed. Frank Lloyd Wright and Dr. Ludd M. Spivey wrote to each other often as they worked on the west campus. In August 1945, Dr. Spivey reminded the architect to include plans for climate control in the administration buildings: "All these buildings must be air-conditioned, and heat must also be provided. Not just fireplace heat." (Courtesy Florida Southern College.)

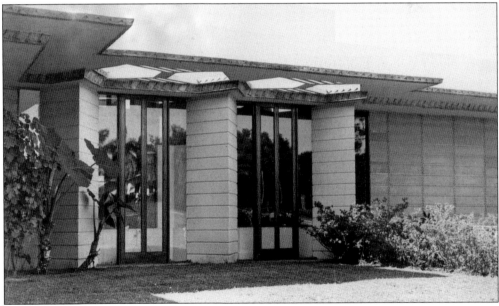

This photograph shows the original tall, cypress-framed windows on the north side of the Emile E. Watson Administration Building. Frank Lloyd Wright was partial to cypress, and the simplicity he exhibited with these windows is indicative of his style of organic architecture. Unfortunately these windows were impractical in this setting, and low walls were added between the columns to raise the sill height for new casements. (Courtesy Florida Southern College.)

The 36-foot-tall steel decorative "light needle" at the north end of the administration buildings rusted and toppled in the early 1960s. The pole, which has 15 lights spaced 18 inches apart descending from the top on two sides, was replaced in 1981 and serves as a unique beacon near the northwest corner of campus. (Courtesy William Carpenter.)

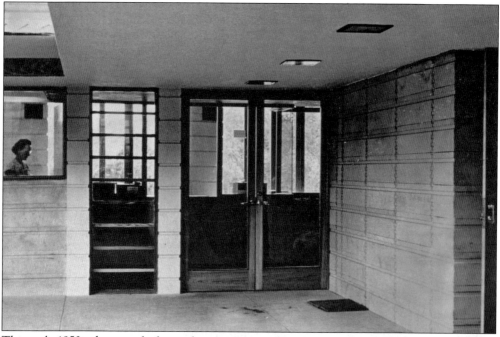

This early 1950s photograph shows the entrance to the present college relations offices and, at far right, a door to the president's office. There is only one cornerstone for the administration buildings, located on the east face of the Emile E. Watson Administration Building near the patio pool and visible in this photograph. It reads, "Emile E. Watson/ Administrative building/ Frank Lloyd Wright architect." It appears that the first line was added after the cornerstone was placed. (Courtesy Florida Southern College.)

70

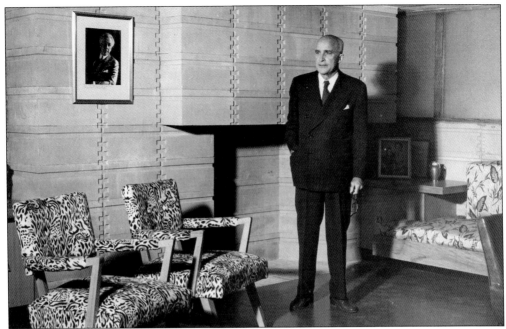

Dr. Ludd M. Spivey posed in his new office in the Emile E. Watson Administration Building in December 1948. A personalized photograph of Frank Lloyd Wright is prominently displayed. Art professor Donna Stoddard indicated that Wright "completely designed Spivey's office with a large fireplace and built-in furniture. Spivey's desk curves around a corner, forming an executive table and desk combination." (Courtesy Sanborn Photo Service, Florida Southern College.)

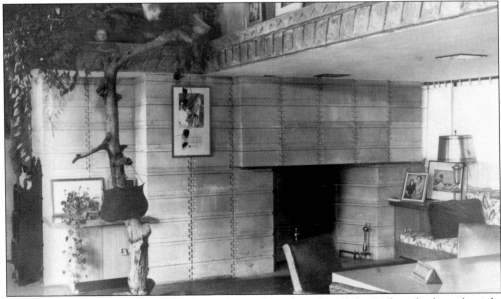

Frank Lloyd Wright's plan has the fascia design from the edge of the Esplanades brought right into the interior of the president's office, intersecting with the fireplace. The photograph of Wright on the wall was taken by Harold Sanborn in October 1951. The administration buildings marked the transition in construction from student labor to Lakeland contractor B. E. Fulghum. (Courtesy Florida Southern College.)

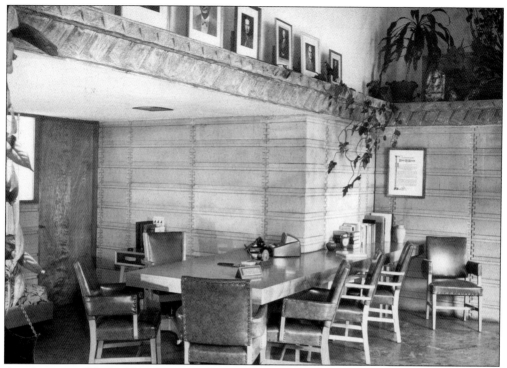

Another view of Dr. Ludd M. Spivey's office shows the built-in desk Frank Lloyd Wright designed for the room and photographs of college trustees displayed above. In an October 1947 letter, Dr. Spivey tells Wright that it will be "another year necessary to finish it and instead of costing $60,000–$70,000 as we thought, will probably cost at least $250,000 or $300,000." (Courtesy Florida Southern College.)

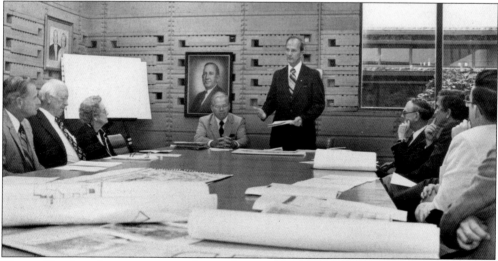

The president's conference room is in the northeast corner of the Emile E. Watson Administration Building. In this 1980s image, Robert A. Davis, president of the college from 1976–1994, speaks to members of the board of trustees. Frank Lloyd Wright used two different types of block in this room, including perforated block embedded with colored glass. The room has a high ceiling, giving it a spacious and comfortable atmosphere. (Courtesy Florida Southern College.)

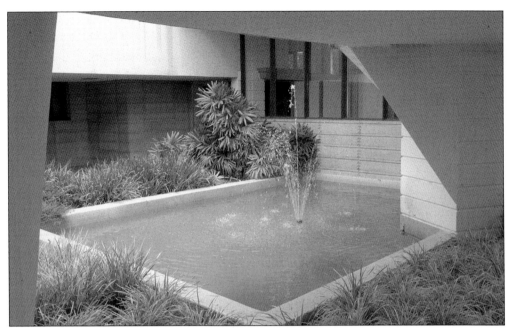

The patio pool extends 20 feet from the wall of the Emile E. Watson Administration Building and is 15 feet wide with a small fountain in the middle. The entrance to the president's office suite is adjacent to the pool. Frank Lloyd Wright designed water features in or around many of his buildings. Water, plants, and landscaping were fundamental to his organic style of architecture, which he used to great advantage in the Esplanade and garden areas of the administration buildings. (Courtesy Wayne Koehler.)

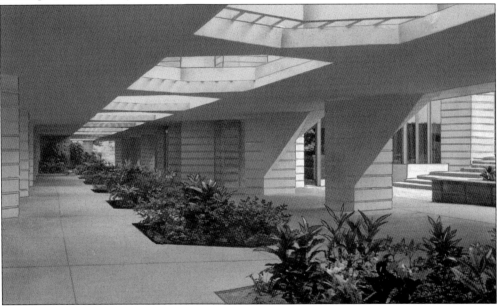

The Emile A. Watson Administration Building (left) and the Benjamin Fine Administration Building (right) were completed in 1948. They are linked by the garden courtyard and the 18-foot-wide double Esplanade. This image was professionally retouched for publication in period viewbooks. (Courtesy Sanborn Photo Service, Florida Southern College.)

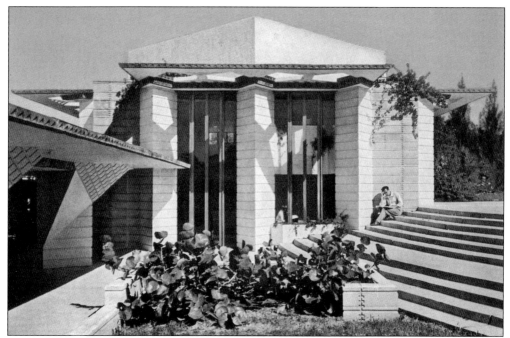

Plants were everywhere in this early view of the Benjamin Fine Administration Building. The Waterdome is just out of view to the right. When autographing a college brochure to Prof. Thomas B. Mack, Frank Lloyd Wright wrote, "Without proper planting, Florida Southern couldn't be Florida Southern." (Courtesy Florida Southern College.)

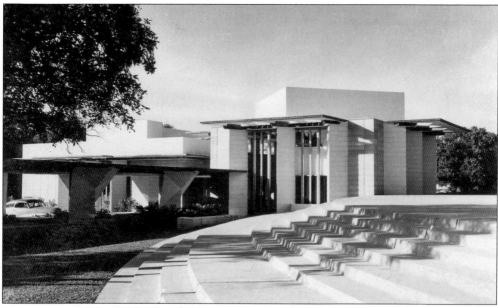

The sweeping J. Edgar Wall Waterdome steps provide a dramatic approach to the administration buildings in the 1950s in one of the most appealing scenes on campus. Frank Lloyd Wright wrote, "In Organic Architecture then, it is quite possible to consider the building as one thing, its furnishing another, and its setting and environment still another. The Spirit in which these buildings are conceived sees all these together at work as one thing." (Courtesy Florida Southern College.)

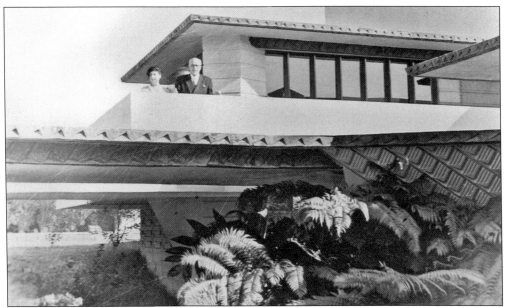

Dr. Ludd M. Spivey poses for a photograph on the balcony of the Benjamin Fine Administration Building. (The woman is unidentified.) A 1,200-square-foot addition, requested by Dr. Spivey and designed by on-site supervisor Nils Schweizer without Frank Lloyd Wright's approval, would, in 1955, be constructed beneath and adjacent to the Esplanade immediately north of this structure, limiting the view of the Waterdome. (Courtesy Saul Rosenblum, Florida Southern College.)

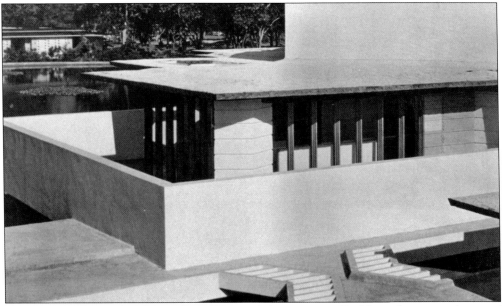

As seen from the roof of the Emile E. Watson Administration Building, this unusual view of the Benjamin Fine Administration Building shows the second-floor balcony patio prior to its reconfiguration as office space and construction of the first floor addition. The Waterdome and seminar buildings are visible in the distance. From this view, the interesting shapes of the concrete roofline and the angles Frank Lloyd Wright used can be observed. (Courtesy Florida Southern College.)

The original portion of the Benjamin Fine Administration Building is two stories tall with a narrow "waterfall" stairway, as seen in the early 1950s. Originally, the offices of the registrar and bursar were located in this building. The doors were cypress set into cypress frames with large glass panes and brass handles. Most interior walls were bare blocks; these were painted and subsequently repainted to match the original color closely. (Courtesy Florida Southern College.)

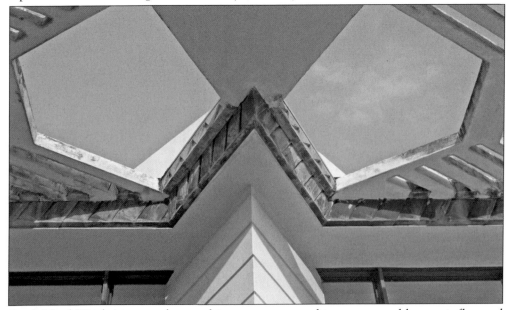

Frank Lloyd Wright's approach to architecture was rooted in nature, and he was influenced strongly by the elements of structural design and the culture of Japan. Wright was captivated by the simplicity and natural forms in Japanese building, landscape, art, and textiles. However, he preferred to use native materials, such as local stone and rocks, and worked with the landscape to create a distinctively American style of architecture. (Courtesy Nora E. Galbraith.)

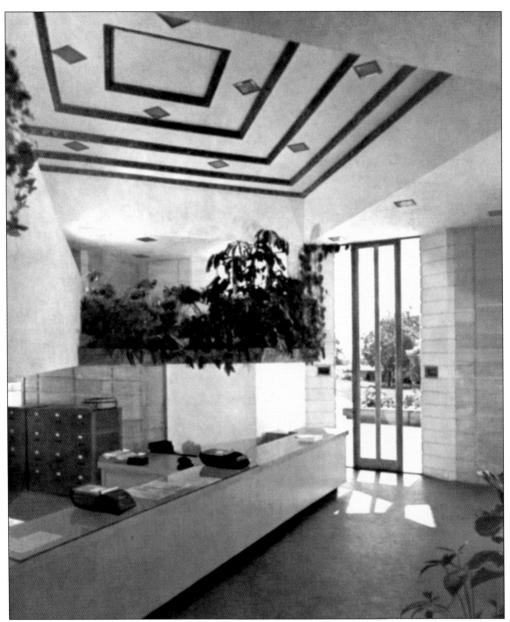

Visitors to the Benjamin Fine Administration Building enter from the 6 foot, 9 inch Esplanade into a two-level lobby with a copper-trimmed ceiling. As seen in the 1956 *Interlachen* yearbook, the office is light and airy, and large plant containers on the second floor blur the line between interior and exterior. As elsewhere on campus, the location of these planters made plant care challenging. J. A. Murray wrote a detailed article about Frank Lloyd Wright's work for the *Tampa Sunday Tribune*, published on March 2, 1952. Murray described the Waterdome project's plans for "a 'waterdome' or canopy of cascading spray tinted with colored lights. The water, from deep wells, will flow from the pool to streams and smaller pools on the campus." Technological and financial challenges plagued the fountain project, and the Waterdome became a large, shallow, tranquil pool. The Waterdome rim is 18 feet from both the administration and seminar buildings. (Courtesy Florida Southern College.)

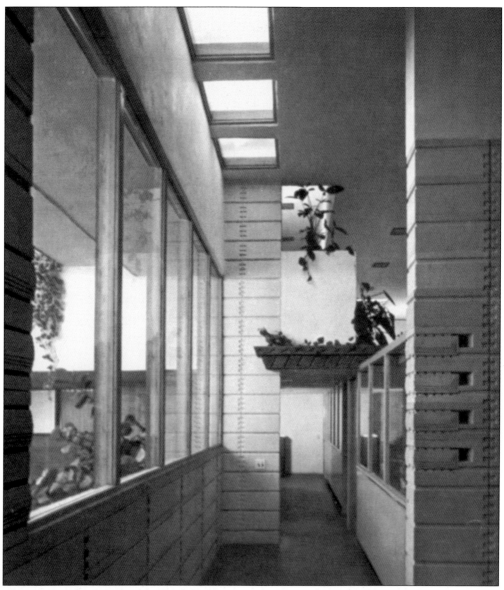

This interior photograph of the Emile E. Watson Administration Building was used in promotional literature throughout the 1950s and in the 1956 *Interlachen* yearbook. The view is from the president's conference room, looking west toward a narrow staircase and the president's office suite. The second floor contains offices and storage space overlooking the first floor rooms. Ground breaking in 1947 for Frank Lloyd Wright's amphitheater and an 80-by-176-foot swimming pool coincided with construction of the administration buildings and the J. Edgar Wall Waterdome. The project was promoted in area news accounts, and fund-raising efforts to "sell" the 5,000 individual seats were somewhat successful. After a lull, the project was revived in April 1950 when, in *The Southern*, the project was described as "on the north-south axis of the waterdome," bordered by a 300-foot lagoon on land extending into the lake. The amphitheater was to have an elevated stage overlooking the pool with dressing rooms below. The project was eventually abandoned, although the lakeside park created as part of the initial dredging lived on as the SUMP—Spivey's Ultra Modern Pool. (Courtesy Florida Southern College.)

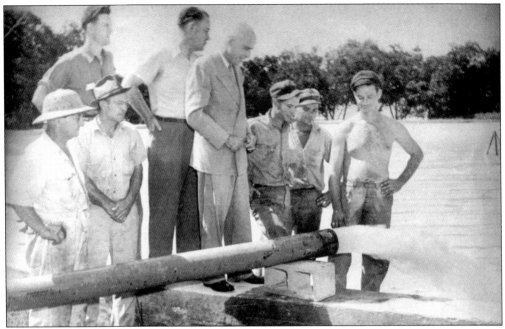

The J. Edgar Wall Waterdome was first filled in early 1948 by a crew from Dansby Well Drilling in Auburndale. Pictured, from left to right, are two unidentified men, Curtis Andrew Dansby, Corning Tolle, Dr. Ludd M. Spivey, Curtis Nelson "Buster" Dansby, and two unidentified men. A similar photograph was published in the 1950 *Interlachen* yearbook. J. Edgar Wall was Tampa's postmaster and chairman of the Florida Southern College Board of Trustees for 35 years. (Courtesy Florida Southern College.)

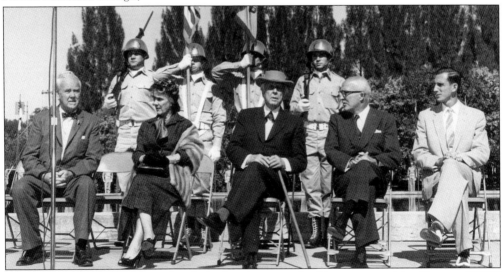

Frank Lloyd Wright was greeted with fanfare during each of his campus visits. Campus ROTC cadets surrounded the J. Edgar Wall Waterdome during this November 1955 ceremony. With Wright (center) on the south Waterdome deck are Chaplain Robert H. MacGowan, Olgivanna Lloyd Wright, Dr. Ludd M. Spivey, and student government president Eugene Roberts. From this vantage point, most of the west campus could be seen. The Waterdome surface is visible behind the dignitaries. (Courtesy Florida Southern College.)

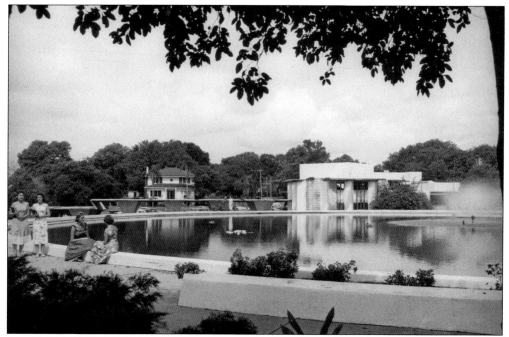

An illustrated November 1952 letter from William R. Lyle of the Florida Southern College citrus department to Dr. Ludd M. Spivey proposed a spillway on the east side of the Waterdome to "keep most of the surface algae or 'scum' out of this pool." Excess water was to pass through a gate into a ditch behind the seminar buildings into a group of citrus trees. (Courtesy Florida Southern College.)

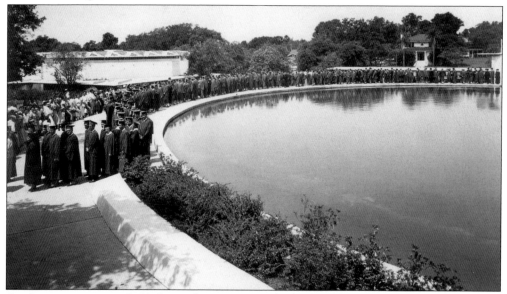

Graduation processionals filed past the unique Frank Lloyd Wright structures. Wright designed the J. Edgar Wall Waterdome as the centerpiece of his Child of the Sun campus collection. The envisioned dome of water would be higher than the adjacent buildings, cooling the surrounding air. The top edge of the Waterdome was a datum from which the vertical positions of the other structures were calculated, forming a three-dimensional design grid. (Courtesy Florida Southern College.)

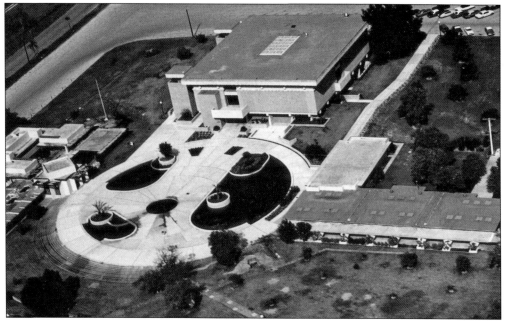

Simultaneous with construction of the new Roux Library between 1966 and 1968, Nils Schweizer filled and covered the Waterdome, creating a 200-foot pebblestone plaza embracing four reflecting pools and seven planters. The area was rechristened the J. Edgar Wall Plaza. Although the seminar buildings had been reconfigured and an addition constructed, this photograph shows the locations of their original, but by then out-of-service, skylights. (Courtesy Florida Southern College.)

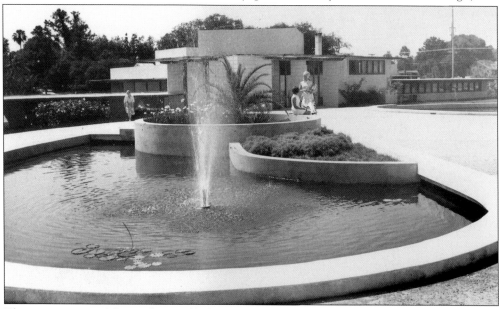

The construction of the J. Edgar Wall Plaza made it easier to walk between buildings on the west side of the campus; but the severe alteration of the Waterdome, together with the construction of the new Roux library, eliminated a key unifying element of Frank Lloyd Wright's design. This image shows one of the pools in the reconfigured area, with the Benjamin Fine Administration Building in the background. (Courtesy Florida Southern College.)

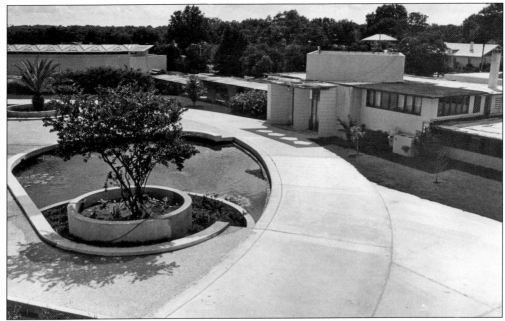

The J. Edgar Wall Plaza overlooked the Thad Buckner Building (formerly the E. T. Roux Library) and the Benjamin Fine Administration Building. When Nils Schweizer designed the new Roux Library, there was a possibility that the Waterdome would be removed entirely; however, the college decided on this plan, covering over the large pool and creating four small pools. (Courtesy Florida Southern College.)

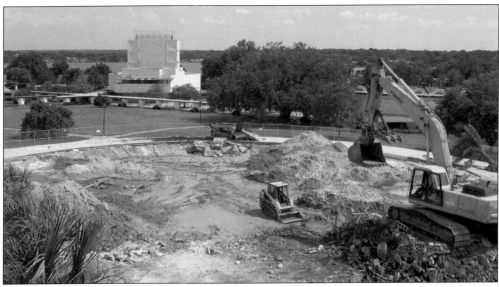

The J. Edgar Wall Plaza was demolished in the summer of 2006 for the purpose of restoring the original Waterdome, thanks in part to support from M. Clayton Hollis, class of 1980. To satisfy current building codes, in 2007, the original basin was replaced with one that conformed closely to the original design and was both structurally sound and slightly shallower. The original 15-inch-wide Waterdome rim remains. (Courtesy Randall M. MacDonald.)

Five

LUCIUS POND ORDWAY BUILDING

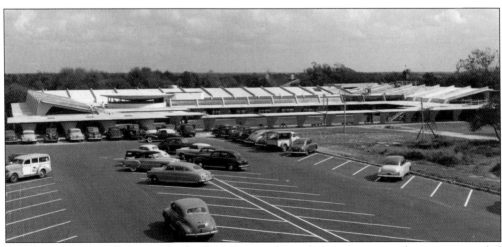

Florida Southern College once had a flourishing industrial arts program, and space was needed to support this curriculum. The industrial arts building received early support from Canadian businessman J. William Horsey, and the completed $552,200 building, begun in 1950, was dedicated to him in March 1952. A dedication plaque was placed near the northwest corner of the building, facing the west courtyard. (Courtesy Harold Sanborn, Florida Southern College.)

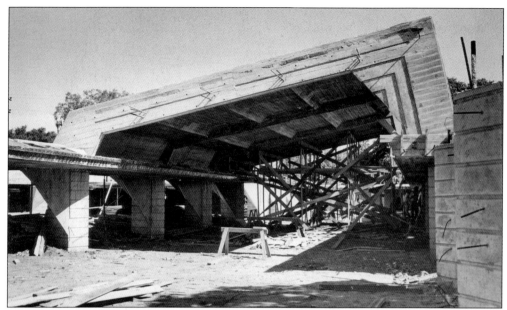

The Frank Lloyd Wright Foundation of Florida Southern College was formed in May 1951 to coordinate fund-raising initiatives to complete the Wright buildings. Benjamin C. Eckardt of Philathea College in London, Ontario, was international chairman, J. William Horsey was international treasurer, and Dr. Ludd M. Spivey was international secretary. The foundation evidently dissolved after J. William Horsey withdrew further support for the industrial arts building. (Courtesy Harold Sanborn, Florida Southern College.)

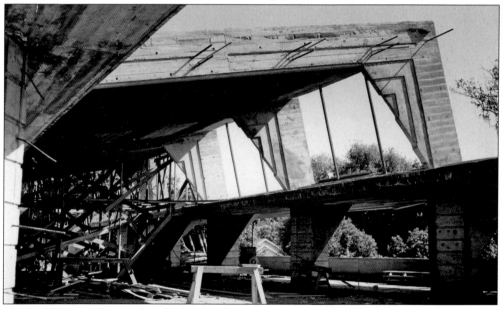

The building was designed with cloisters facing two courtyards and a spacious refectory. It is reminiscent on a grand scale of Frank Lloyd Wright's Taliesin West campus in Scottsdale, Arizona, completed several years later. These construction views are of the east section, facing north. The building was rededicated as the Lucius Pond Ordway Building in 1956 and is best known by that name, "Ordway." (Courtesy Harold Sanborn, Florida Southern College.)

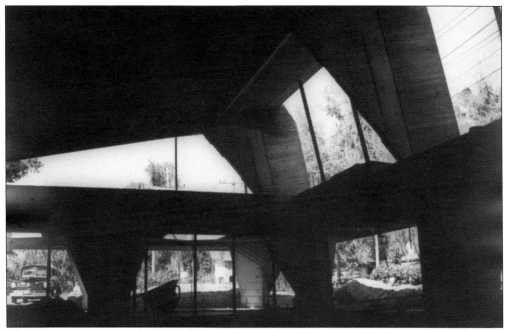

The northwest section of the building was designed to house the art department and drafting studios. Clerestory windows were used throughout, as Frank Lloyd Wright had designed in many of his other commercial and residential buildings. In this structure, they left valuable wall space for blackboards, bookcases, shelving, and other equipment. Window frames were painted red. (Courtesy Harold Sanborn, Florida Southern College.)

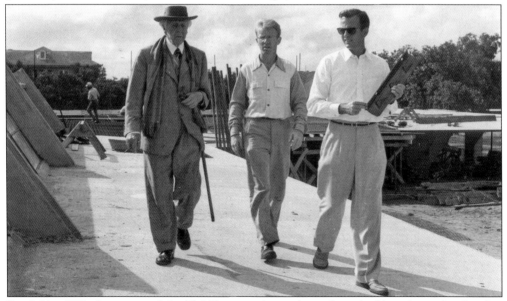

Frank Lloyd Wright inspected the 30,000-square-foot industrial arts building during his October 24, 1951, campus visit. Joining him was his associate and on-site supervisor Robert Eugene Cross (far right) and another unidentified associate. In 1955, Wright said of this building, "I don't think I've ever done any building that is so completely strong and adapted to its purpose." (Courtesy Harold Sanborn, Florida Southern College.)

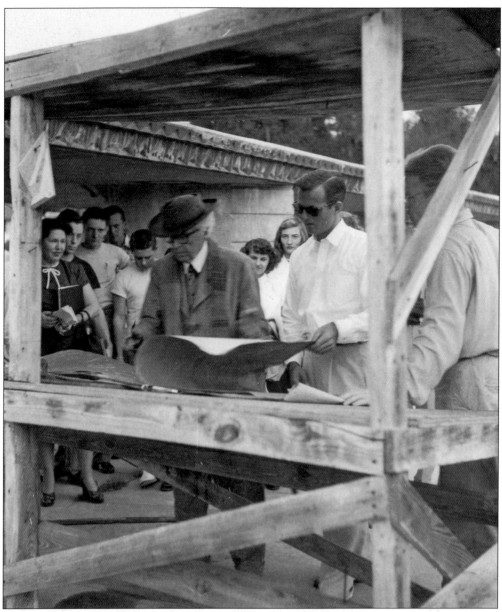

Frank Lloyd Wright reviewed the building plans during his October 24, 1951, inspection, as Prof. Donna Stoddard (left) and a group of students looked on. The building project had been financially draining for Florida Southern College, and the correspondence between Dr. Ludd M. Spivey and Wright is filled with allusions to the difficulties both men faced. Dr. Spivey was barely able to pay his faculty during World War II, and Wright deserved to be paid well for his services. An exchange during February 1950 hints at the tension between the two men. Dr. Spivey forwarded a check for $500 and pleaded with Wright to return on-site supervisor Kenneth Lockhart to the campus. He was counting on Wright to appear at the Founders' Week celebration and pinned his hopes on an article in *Life* magazine to help secure new students. Wright's terse but sympathetic reply: "Dear Dr. Thanks for the 'Widow's Mite.' " (Courtesy Harold Sanborn, Florida Southern College.)

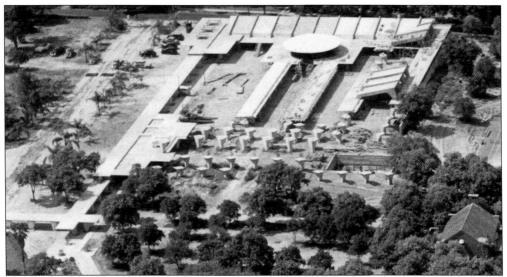

This *c.* 1951 photograph shows the industrial arts building with 127 Esplanade columns. In 1949, Dr. Ludd M. Spivey sent Frank Lloyd Wright these instructions for the building: "Need large space for recreation . . . no place to hold a student dance on campus. Don't make cafeteria expensive. Keep it simple. Provide place for self-service and eliminate waiters, etc. Cost should not exceed $150,000." (Courtesy Harold Sanborn, Florida Southern College.)

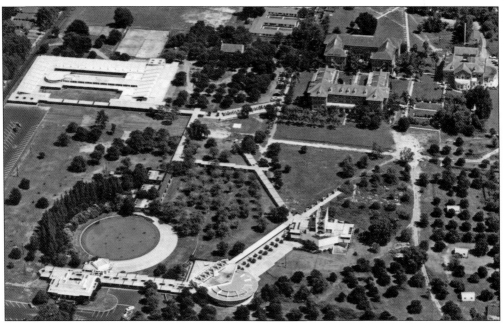

The west campus as it existed late in 1952 was nearly complete, save for the Polk County Science Building and the William H. Danforth Chapel. This view looks across the campus eastward, past the Child of the Sun buildings and toward the dormitories. The new 275-car parking lot extending along the north edge of campus helped accommodate a growing enrollment. (Courtesy Florida Southern College.)

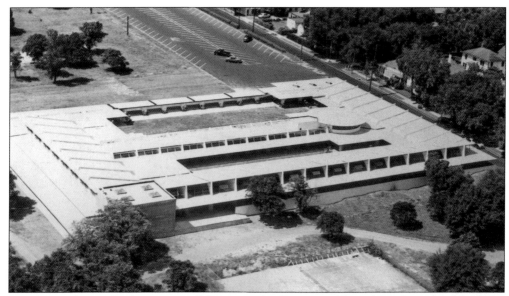

Seen here in late 1952 when it was still known as the Horsey Building, the industrial arts building features two grass courtyards. The eastern courtyard is between the east and west sections of the building and measures approximately 180 feet by 24 feet. The western courtyard is between the west section of the building and the adjacent Esplanade. This attractive space is approximately 192 feet by 60 feet. (Courtesy Florida Southern College.)

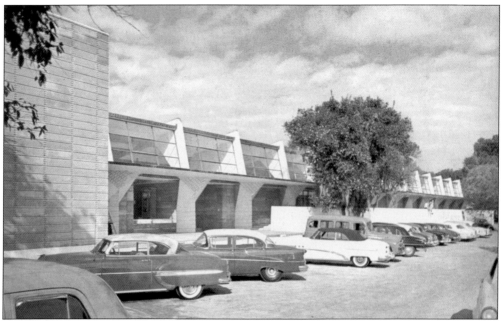

This photograph from the 1956 *Interlachen* yearbook shows the east facade of the Ordway building. A basement entrance flanked by two 9-foot-tall planters is accessible from this parking lot. The basement is currently used by the custodial staff but once was a small machine shop. Prof. Richard R. Burnette Jr., a faculty member since 1962, remembers having his lawn mower serviced there. (Courtesy Florida Southern College.)

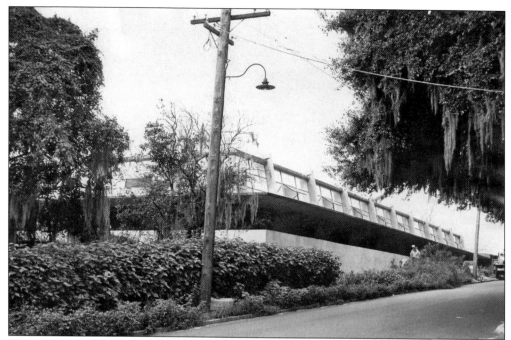

The proximity of the Ordway building to McDonald Street is evident in this image from the 1950s. The school is located near the center of Lakeland, and public roads run through and around the campus. Unlike the other structures Frank Lloyd Wright built at the college, the Ordway building is adjacent to a busy thoroughfare. The visible north and east porches of the building are 12-feet wide. (Courtesy Florida Southern College.)

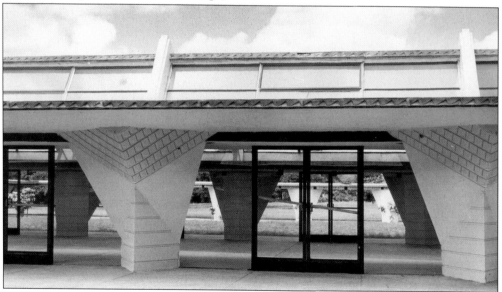

The west pavilion section of the industrial arts building was an empty space when this photograph was taken, probably in 1953 before it was used as a student lounge. Hattie Horwitz wrote of the building: "Long, low and muscular, the buildings remain in character, essentially a widened and heightened version of the esplanade with walls added." (Courtesy Paul Wille, Florida Southern College.)

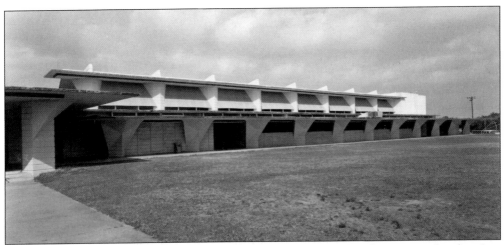

In 1979, the Esplanade and this south face of the building seemed to flow into each other. It is fascinating to walk through and around this building. It was designed with greater simplicity than Frank Lloyd Wright's earlier campus buildings, which typically contained multiple configurations of tapestry blocks, embedded colored glass, and lacey cutouts. This building has a unique Wright look and feel. (Courtesy Walter Smalling, Florida Southern College.)

Pictured here are bundles of foam panels near the southeast corner of the building, part of a 1980s remodeling project that included energy-saving measures. The steel and glass clerestory windows, which by this time had been shaded with large immovable panels, were replaced with translucent fiberglass units that reduced the strong sunlight and solar heat. (Courtesy Florida Southern College.)

The Fletcher Theater in the Ordway building, a charming theater-in-the-round, restated the round forms used elsewhere on the campus. Frank Lloyd Wright included many interesting details, such as the angled window just under the round roof, the circular cutout above the windows, and the running triangles on the fascia. The glass clerestory windows were replaced with translucent fiberglass when the building was remodeled. (Courtesy Nora E. Galbraith.)

Located at the north end of the east courtyard is another example of a Frank Lloyd Wright water feature. Wright's philosophy, partly influenced by the time he spent in Japan, was that people should live in balance with nature, and he believed every building should have some element of water. This pool, which was designed with a small fountain, measures 12-by-12 feet. (Courtesy Nora E. Galbraith.)

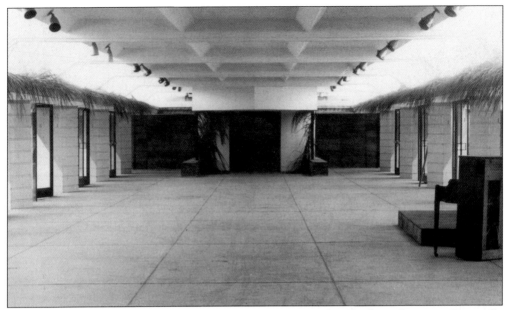

The west pavilion section is shown shortly after construction with early plant adornment. Especially while serving as a student lounge, this room was shown in many yearbook images. The unusual object at the north end is the back of the Fletcher Theater staircase and elevated projection room. That small fraction of the pavilion remains recognizable, part of the history and political science department office suite. (Courtesy Florida Southern College.)

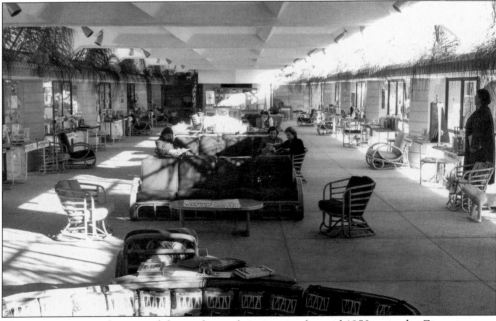

The primary space designated for student relaxation in the mid-1950s was the Zimmermann Lounge, named for college trustee G. Floyd Zimmermann Sr. The lounge occupied the extensive pavilion space and was equipped with a television, piano, ping-pong table, and soft drink machine. The lounge was underutilized, and in 1958, it was sectioned off for classroom and office space. (Courtesy Paul Wille, Florida Southern College.)

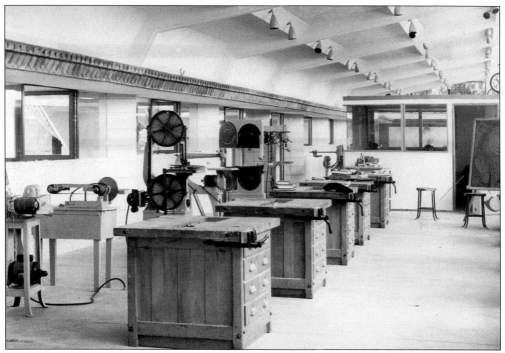

Located in the east section, this woodworking shop supported courses in industrial arts education. Each workstation was well-equipped with the necessary tools of the trade. Seen here in 1954, the shop contained office and tool storage spaces, beyond which was a metalworking shop. There was quite a bit of natural light, but notice all of the lamps attached to the ceiling. (Courtesy Florida Southern College.)

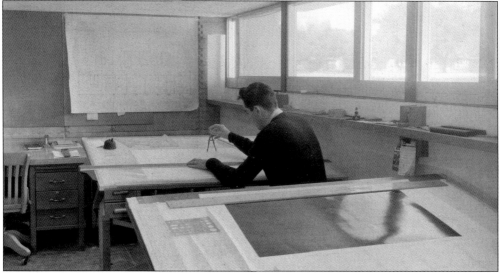

This photograph of a drafting classroom in the Ordway building likely dates from the early 1960s. In October 1957, speaking to the Michigan Society of Architects, Frank Lloyd Wright said, "There is only one university in the United States that has an American campus and that is Florida Southern College. Not one of the others has one that really represents the new thought, our thought, our belief in humanity." (Courtesy Florida Southern College.)

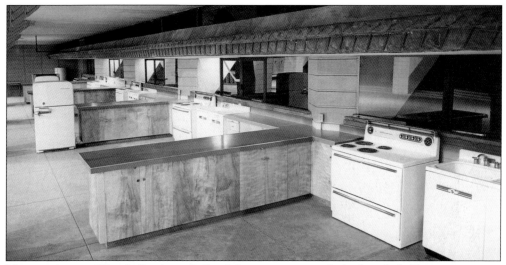

Many graduates of Florida Southern College's "creative program," which included home economics courses, went on to teach home economics in high schools. These kitchens were located in the south section of the Ordway building. Prof. Richard R. Burnette Jr. remembers these kitchens as a source of nourishment; faculty members regularly sampled student cooking. The industrial arts curriculum was phased out in the 1960s. (Courtesy Florida Southern College.)

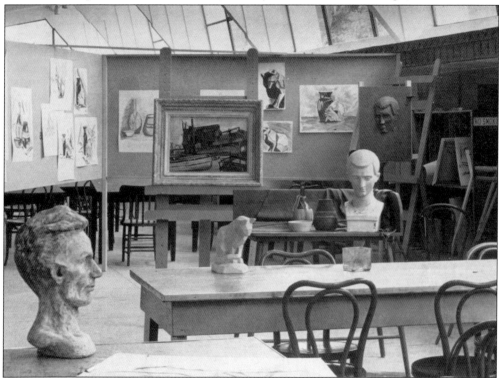

Frank Lloyd Wright designed art studios in this building to be spacious and with enough room for many varied art media. The room is open and flooded with northern light, which is relatively even and consistent. The clerestory windows left the walls free with plenty of space for easels and shelves for paint, props, brushes, and storage. (Courtesy Florida Southern College.)

The 1957 Christmas Dance was in the south lobby originally designated for the refectory. This photograph is from the 1958 *Interlachen* yearbook. The caption reads, "One of the greatest hours of the year . . . the wonderful Christmas dance at the Ordway Building." This room was just what the school needed, as with a growing enrollment there had not been a sufficiently large space for a formal dance. (Courtesy Florida Southern College.)

The south lobby of the Ordway building is seen in this current view from the second-story psychology department offices. The lobby is used primarily for student testing. Adjoining the space are offices for faculty members of sociology and criminology, and the college testing office, which was designed to accommodate sewing classes. (Courtesy Nora E. Galbraith.)

Frank Lloyd Wright's personal philosophy held that a building for learning made with beauty, simplicity, unity of design and craftsmanship, and integrated with nature would produce superior students who would, in turn, be better people. His speeches, essays, and letters to Florida Southern College's students always touched on this philosophy. Many classrooms created in the Ordway building were 18 feet deep, built to the scale of the adjoining Esplanade columns. (Courtesy Florida Southern College.)

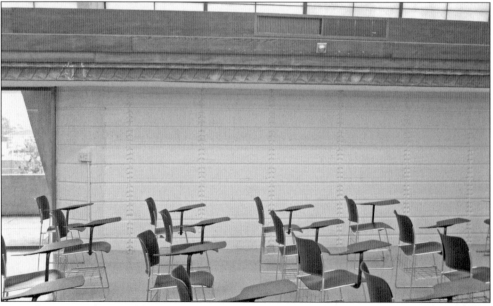

An architect's rendering of the industrial arts building in the 1947 *Interlachen* yearbook resembles, in large measure, the building that was constructed. According to the yearbook, the building was forecast to include "refectory, recreation, craft shops, pavilion, draughting room, and lecture amphitheater." These are the current student desks in the east section of the Ordway building. (Courtesy Nora E. Galbraith.)

Formerly the welding shop, the college print shop is located in the northeast corner of the Ordway building and features an unusual second floor office. A portion of this shop was previously used as a photographers' darkroom. The college has remodeled spaces as programs and needs have evolved. (Courtesy Nora E. Galbraith.)

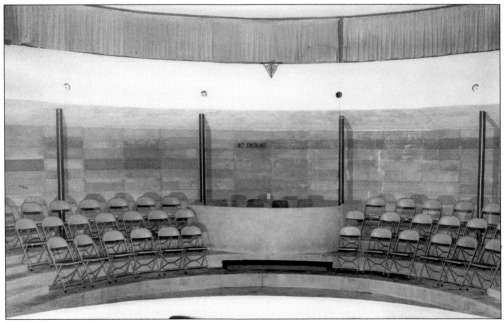

The Fletcher Theater is located at the north end of the west section. The clerestory windows were curtained for many years. The ceiling was designed by Frank Lloyd Wright to produce efficient acoustics and included a centered, down-facing circular light structure. The first production after its February 1952 dedication was *Arms and the Man*. (Courtesy Florida Southern College.)

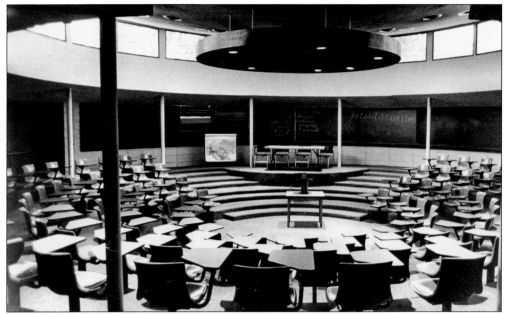

Totalitarianism was the topic of the day in this 1970s view of Fletcher Theater, seen with immovable desk seats for political science classroom use, a function it still serves. The theater was named for beloved Prof. William Gregory Fletcher. Fletcher, who died in October 1952, was one of the college's oldest graduates, having received his degree when the college was located in Leesburg. (Courtesy Florida Southern College.)

This recent photograph shows a production platform and projection room accessible by a narrow staircase bordered by a tall planter in the Fletcher Theater. Frank Lloyd Wright's plans did not include any dressing rooms, making it awkward to stage productions, but the college theater company, the Vagabonds, did produce many shows for the school in this circular room before a new theater was built. (Courtesy Nora E. Galbraith.)

Six

WILLIAM H. DANFORTH
CHAPEL

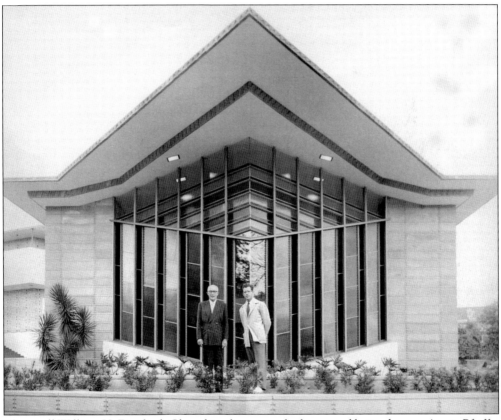

The small William H. Danforth Chapel is adjacent to the larger and better-known Annie Pfeiffer Chapel, and in many ways, it is every bit as intriguing. The only entrance is on the north side of the building, steps away from and facing the Annie Pfeiffer Chapel. This view of the west facade shows Dr. Ludd M. Spivey with on-site supervisor Nils Schweizer in 1955. (Courtesy Florida Southern College.)

The ground-breaking ceremonies were in May 1954, and this image shows the Gordon Brothers Concrete Company pouring the floor slab. The walls were built using tapestry blocks, but amber glass inserts were only used in blocks near the entrance. This is one of many photographs documenting Frank Lloyd Wright's work by Paul Wille, who served as the college photographer for 29 years. (Courtesy Paul Wille, Florida Southern College.)

The William H. Danforth Chapel is the only instance in which Frank Lloyd Wright used traditional, leaded stained glass on the campus. This may be the last time Wright used leaded glass in his career. Largely unchanged since it was constructed in 1954 and 1955 at a cost of $50,000, Danforth Chapel is the most pristine of the Child of the Sun buildings on the Florida Southern campus. (Courtesy Paul Wille, Florida Southern College.)

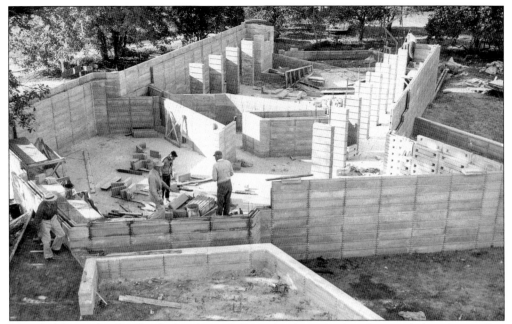

Intended for use by the Florida Southern College chaplain, the first floor includes a large office with a huge fireplace and a small utility room, the spectacular sanctuary at the west end of the structure, and a large gallery reached by a clever, small staircase angled into the block wall. (Courtesy Paul Wille, Florida Southern College.)

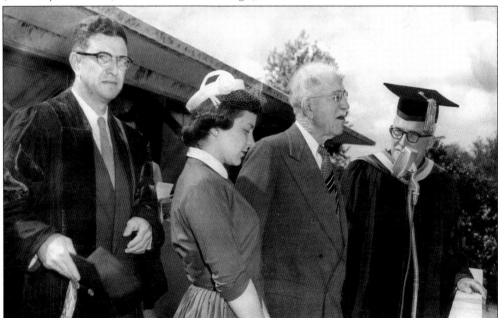

William H. Danforth, 84 years old at the time of the March 4, 1955, dedication, traveled to Lakeland to present the building to the college. Pictured, from left to right, are Vice Pres. Charles T. Thrift Jr., an unidentified student, Danforth, and Dr. Ludd M. Spivey. The Danforth Foundation, established by the Ralston Purina Company founder, sponsored construction of campus chapels across the United States. (Courtesy Florida Southern College.)

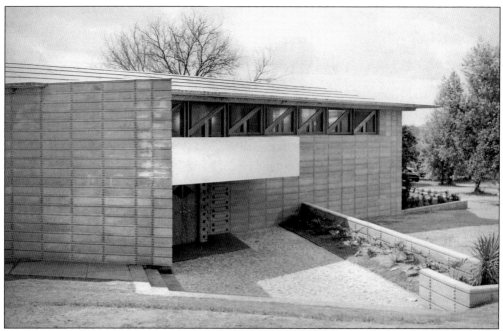

The William H. Danforth Chapel is entered through a pair of northern-facing wooden doors hung with Frank Lloyd Wright's signature piano hinges. The doorway is 4 feet wide and is approached from under a balcony that matches the Esplanade height and echoes the overhang over the east entrance of the E. T. Roux Library to the northwest, easily visible from this spot. (Courtesy Paul Wille, Florida Southern College.)

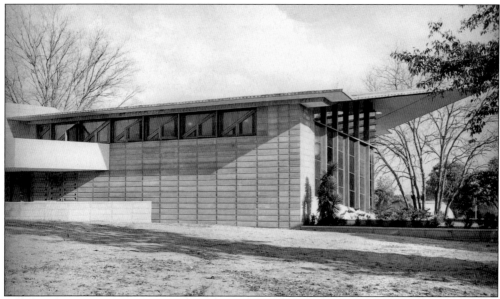

The cornerstone is in the wall west of the entrance. It reads: "Danforth Chapel/ Frank Lloyd Wright architect." A second tablet is inside the lobby. It reads: "The Danforth Chapel/ Dedicated to the worship of God/ With the prayer/ That here/ In communion with the Highest/ Those who enter may acquire the spiritual power/ To aspire nobly/ Adventure daringly/ Serve humbly." (Courtesy Paul Wille, Florida Southern College.)

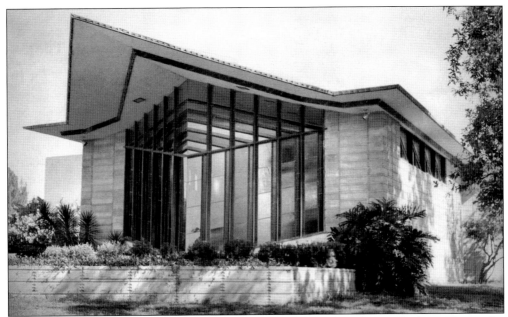

The Danforth Chapel, viewed from the southwest, echoes the prow design of a ship, a design also evident in Frank Lloyd Wright's 1947 Unitarian Meeting House in Shorewood Hills, Wisconsin. Also known as the Minor Chapel, the structure is framed in native Florida tidewater red cypress woodwork. Fading rays of the setting sun illuminate the interior through the stained-glass western wall. (Courtesy Florida Southern College.)

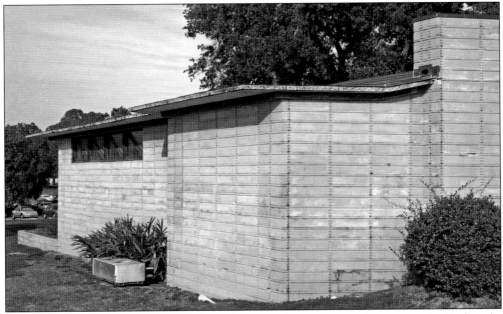

The south and east walls of the William H. Danforth Chapel are visible from the Esplanade. This is the only one of Frank Lloyd Wright's buildings at Florida Southern College not physically connected to the Esplanade. The closest Esplanade section is 90 feet from the entrance along a 4-foot-wide sidewalk. By comparison, the Danforth entrance is closer to the southwest entrance of Annie Pfeiffer Chapel, at 70 feet. (Courtesy Nora E. Galbraith.)

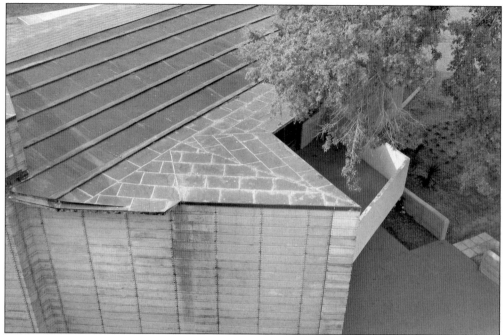

This bird's-eye view of the William H. Danforth Chapel was captured from the roof of the Annie Pfeiffer Chapel. The smaller structure is set at a 30-degree angle from the Annie Pfeiffer Chapel but is built on the same 6-foot-square grid. A copper roof was installed in the 1990s, completing Frank Lloyd Wright's vision for the building. (Courtesy Randall M. MacDonald.)

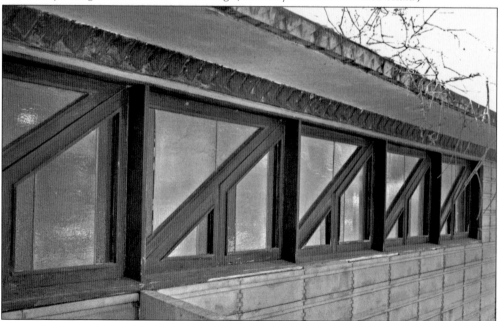

Stained- and leaded-glass clerestory windows help light the interior. The windows shown here are on the north side of the chapel, viewed from the balcony, which is accessible through a wooden door that was also accented with stained and leaded glass. The glass is clear, amber, and red; matching colors were used in the pulpit. (Courtesy Nora E. Galbraith.)

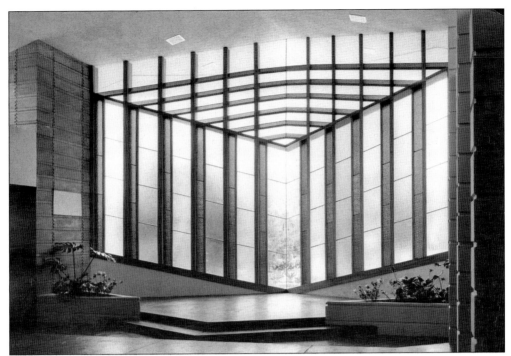

Planters on either side of the rostrum are reminiscent of those that flanked the original pulpit in the Annie Pfeiffer Chapel. There are storage closets at the front of the sanctuary, and each houses a large speaker behind a grille such as is visible on the wall above the planter in this 1955 photograph. (Courtesy Paul Wille, Florida Southern College.)

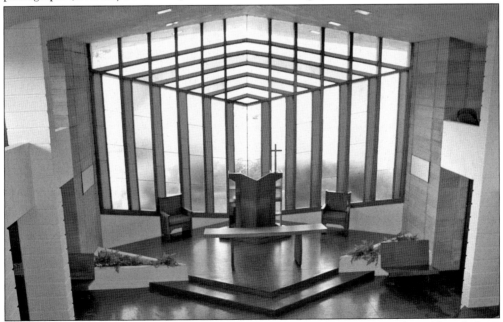

The William H. Danforth Chapel has aged gracefully. This 2006 photograph could easily have been taken 50 years earlier, given the similarities between this and the previous image. The interior is bright and retains Frank Lloyd Wright's painted red floor. (Courtesy Wayne Koehler.)

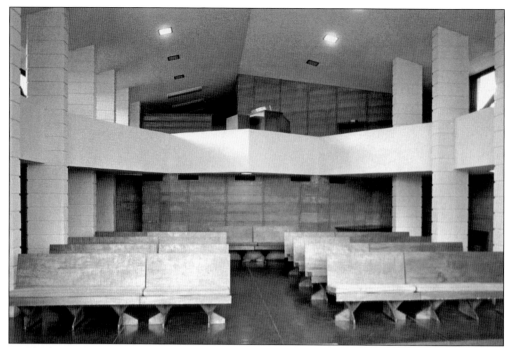

Frank Lloyd Wright's pews for William H. Danforth Chapel, made of three-quarter inch plywood, were constructed by students in woodworking classes. They were made in two widths for either two or three persons. The red-covered cushions were also assembled on campus. The chapel interior is shown here in its original configuration. The staircase to the gallery level can be seen at the left, behind the rear pews. (Courtesy Florida Southern College.)

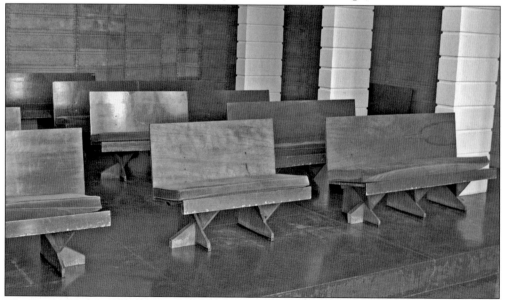

The original Danforth Chapel pews and cushions remain in the sanctuary and have held up well, despite their age. Frank Lloyd Wright was well-known for designing furniture to go in his buildings. Nils Schweizer called Wright "a romantic, and a major part of his genius lay in his visualization of the interrelationships of many details." (Courtesy Nora E. Galbraith.)

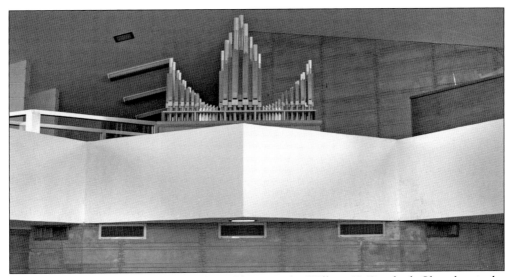

The organ on the second level is a recent addition to the William H. Danforth Chapel, as is the low aluminum-framed glass parapet at the top of the stairwell. Along with occasional weddings and religious services, the Danforth Chapel is also used for academic presentations and fraternity and sorority gatherings. (Courtesy Nora E. Galbraith.)

The large fireplace on the east wall of the first floor office differs in design and in scale to space from those in E. T. Roux Library and the Emile E. Watson Administration Building. The firebox in nearly 4 feet tall, and logs rest on a heavy metal grate. A closet behind the fireplace is accessible from both sides and is large enough to walk entirely through. (Courtesy Nora E. Galbraith.)

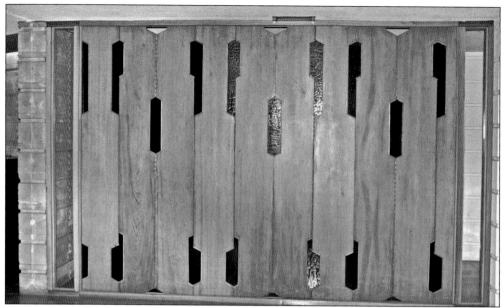

Cypress accordion doors with crimson stained-glass inserts separate the first floor office from the lobby. The doors are decorative but not functional. To make the office secure, strips of wood have been affixed along the tops and bottoms of these doors, permitting access only through the adjacent office door. (Courtesy Nora E. Galbraith.)

A large classroom fills the east section of the gallery level; this photograph shows the south end of that room. The classroom has traditionally been used for instrumental and voice instruction, and choral presentations are made from the gallery. Small storage closets are along the east wall, and early built-in shelving remains. (Courtesy Nora E. Galbraith.)

Seven

POLK COUNTY
SCIENCE BUILDING

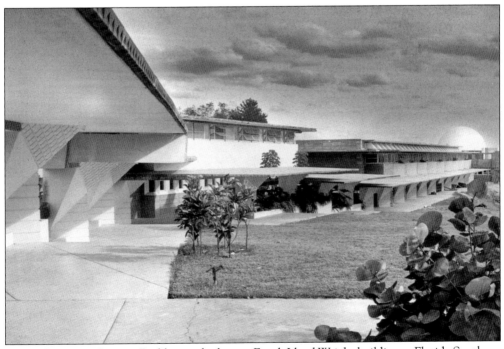

The Polk County Science Building is the largest Frank Lloyd Wright building at Florida Southern College. It is just over 400 feet in length. The building is known locally as "Polk Science." It functions as one structure but has four distinct sections, including physics and mathematics, biology and chemistry, cosmography (earth sciences and astronomy) with its domed planetarium, and what was historically the citrus department section. (Courtesy Florida Southern College.)

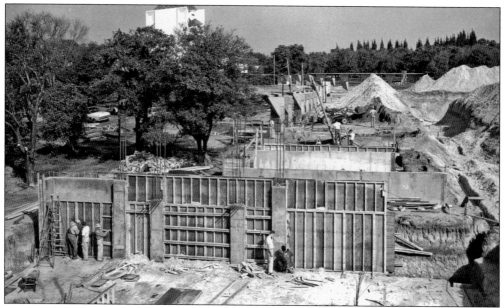

The Polk County Science Building was constructed between 1953 and 1958 at a cost of $1 million, more than $225,000 of which was raised through an initial local campaign. Florida Southern College is located in Polk County, a center of the citrus and phosphate industries. This early view faces north and shows work performed on the southernmost section, which was eventually topped by Frank Lloyd Wright's only constructed planetarium. (Courtesy Paul Wille, Florida Southern College.)

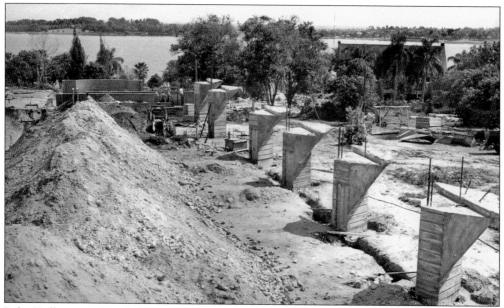

Lake Hollingsworth and the president's home are visible past the construction site of the Polk County Science Building about 1954. The columns on the west side of the building are 18 feet apart and not only support a lengthy Esplanade section integral to the structure, but are also topped by tall triangular planters accessible from upstairs windows. (Courtesy Paul Wille, Florida Southern College.)

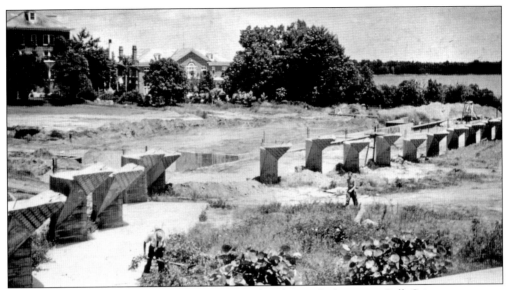

Narrow basement utility rooms were constructed underneath the entire Polk Science structure, and during the cold war, civil defense supplies were stored in these joined tunnels. Food, water, blankets, and other survival supplies were stored there for many years. On Halloween each year, students were invited into the "Haunted Lab" beneath the building. The basement rooms are visible in this photograph, looking southeast. (Courtesy Florida Southern College.)

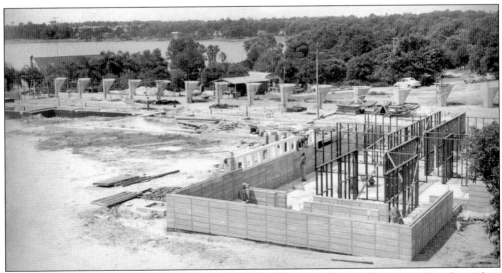

The citrus section of the Polk County Science Building was designed, in part, based on ideas submitted by professors William R. Lyle and Thomas B. Mack. The plan included one large classroom, a laboratory classroom, a soil and fertilizer laboratory, a fruit-testing room, two offices, and a greenhouse. The section extends more than 100 feet east from the central building and was completed in 1956. (Courtesy Paul Wille, Florida Southern College.)

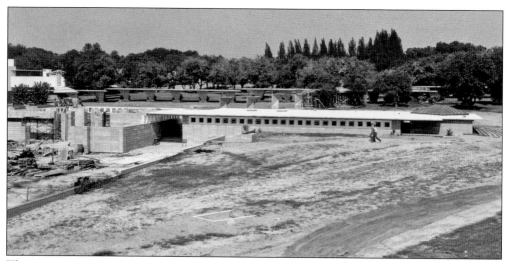

The citrus section is a single level cut into the hillside to more than 4 feet below grade. This in-ground placement was problematic, as rainwater seeped into the building in spite of the best efforts of college maintenance. Prof. Thomas B. Mack referred to his 32 years in the building as "living like a troglodyte in a cave." In the 1970s, swales were built to divert rainwater around the building, and the severe moisture problem was mitigated. (Courtesy Florida Southern College.)

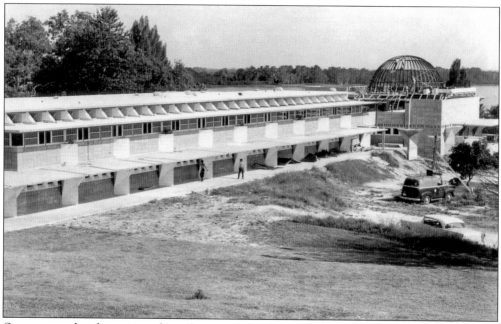

One can see the planetarium dome framework being assembled in this photograph dating from about 1957. The nine triangular planters atop the Esplanade columns were already in use. The space occupied by vehicles in this photograph has held subterranean building systems equipment since an $11 million renovation project in 1999–2000. (Courtesy Florida Southern College.)

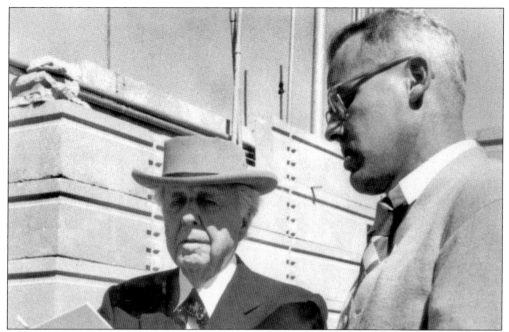

Frank Lloyd Wright and Prof. Thomas B. Mack confer during the architect's November 1955 inspection of the Polk County Science Building. In 1985, Professor Mack related a story about Wright and landscaping: "[Wright] commented about the beauty of the palms in the Florida scene. However, when I asked if he would like to see palms around his buildings, he immediately lost interest in them. 'Don't plant those ugly giants around my buildings!' " (Courtesy Florida Southern College.)

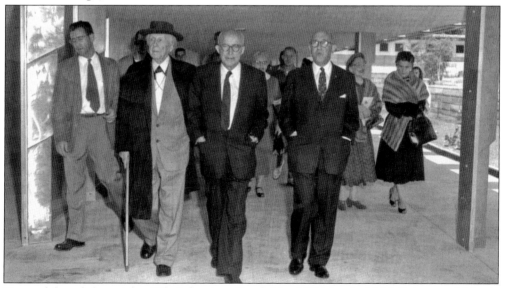

Pictured from left to right, Nils Schweizer, Frank Lloyd Wright, Ludd M. Spivey, and Morris Fishbein of the American Medical Association lead a group past aluminum columns and toward the planetarium in the not-quite-completed Polk County Science Building during Founders' Week in March 1957. Also visible are, from left to right, Clara Spivey, Anna Fishbein, and Olgivanna Lloyd Wright. The ceiling height here is 6 feet, 8 inches. (Courtesy Florida Southern College.)

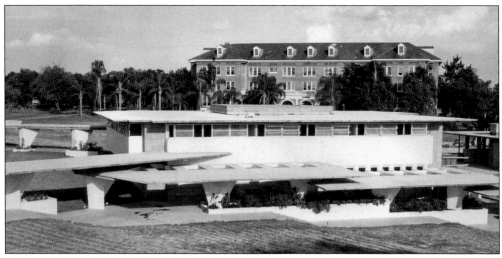

The physics and mathematics section of the Polk County Science building was the second completed. This image depicts the west side of the building with the Joseph-Reynolds Hall, a women's dormitory (1922), in the distance. The Polk Science cornerstone is located on an exterior wall west of the entrance to this section. It reads: "Cosmography . . . physics building/ Erected/ In memory of/ Israel Sobiloff/ March 8, 1957/ Frank Lloyd Wright architect." (Courtesy Florida Southern College.)

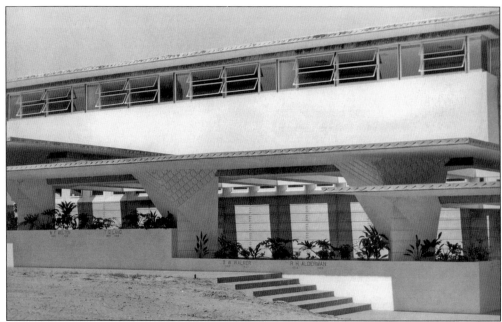

Along the west side of the physics and mathematics section of the Polk Science building is the "President's Walk and Stoa," defined primarily by the lengthy planter under the Esplanade. The planter is engraved with the names and years of service for each of the college's first 15 presidents. The planter itself measures 63 feet by 7 feet. (Courtesy Florida Southern College.)

The president's walk was dedicated during Founders' Week festivities on March 9, 1956. The southernmost planter face had the name of Dr. Ludd M. Spivey and the year 1925, when he arrived on campus; the year 1957 was added upon his retirement. Dr. Spivey's name was subsequently replaced by that of president Robert A. Davis (1976–1994), and Dr. Spivey's name was inscribed on the planter's west face. (Courtesy Florida Southern College.)

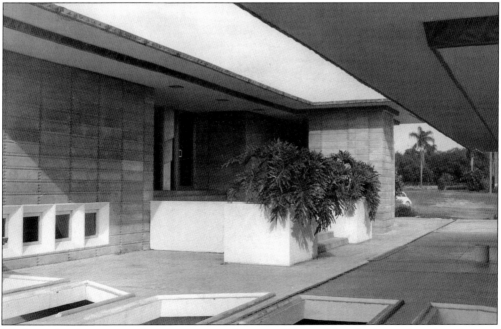

Mathematics department classrooms are on the second floor of the physics section. A stair tower is located beyond large planters flanking the entrance, and doors from the adjoining section provide additional access. For nearly 40 years, a sloped ramp extended from the ground to this level on the east side of the building; this was removed during the 1999–2000 renovation project. (Courtesy Florida Southern College.)

Frank Lloyd Wright's architecture has provided a picturesque backdrop for photographers. Shown here, from left to right, in this October 1961 image are Margaria Lichtner, Marsha Kindred, Frances Willis, and Mary Thrift. (Courtesy Perkins Photographers, Florida Southern College.)

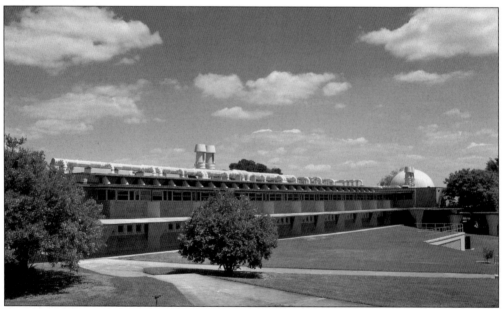

The most dramatic exterior evidence of the 1999–2000 renovation of the Polk County Science Building was the installation of the massive venting systems atop the building. These were the contemporary architect's solution to bringing the laboratories' ventilation up to current safety standards, but they altered the look of the building, as seen in this 2005 photograph. (Courtesy William Carpenter.)

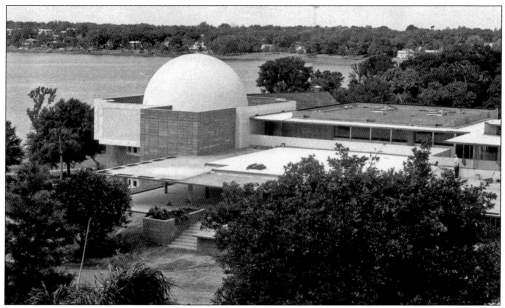

This photograph of the Polk County Science Building was taken from Joseph-Reynolds Hall. The open balcony on the east side of the top floor was later enclosed, and a patio used for nighttime viewing by astronomy classes was added on the white, raised roof adjacent to the balcony. A loading dock and large planter are visible near the bottom center of this image. (Courtesy Florida Southern College.)

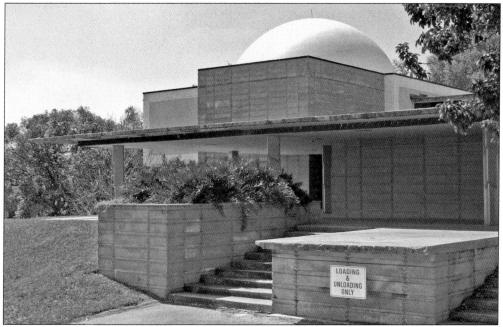

The small loading dock of the Polk County Science Building is just over 9 feet wide. It is flanked by two large planters and has steps on either side leading to the ground level of the building. Besides the novelty of a loading dock designed by Frank Lloyd Wright, this spot offers a contrast of architectural shapes, angles, and textures. (Courtesy Nora E. Galbraith.)

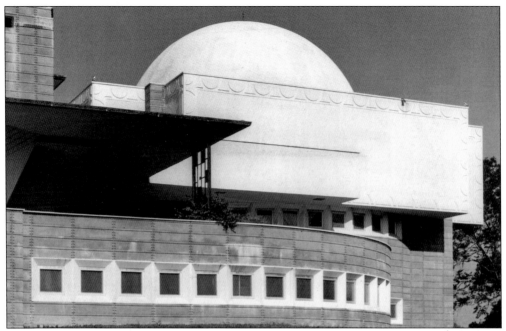

The planetarium dome rises high above the surrounding landscape on the west side of the cosmography section of the Polk County Science Building. Patio seating is inside the top of the curved wall, and a basement level entrance, not visible in this image, is to the left. (Courtesy Florida Southern College.)

Dean Holiday has been a familiar sight to the Florida Southern community since 1965, appearing most years atop the planetarium dome. The brainchild of business manager David Readdick, Dean Holiday is a 12-foot, canvas-covered snowman's head topped by a mortarboard. A small matching snowman float has spread seasonal cheer in many Lakeland Christmas parades. (Courtesy Florida Southern College.)

Frank Lloyd Wright provided patio seating at the southwest corner of the cosmography section of the Polk County Science Building. The seating provides a casual spot to relax between classes and can accommodate class-sized groups awaiting planetarium presentations. (Courtesy Nora E. Galbraith.)

The astronomy patio created on the rooftop of the cosmography section during the 1999–2000 renovation provides the vantage point for this current view of Polk Science. Facing north, portions of the venting system may be seen atop the central building and former citrus section. The walled porch in the center was formerly part of the longer, open porch that extended along the facade. (Courtesy Nora E. Galbraith.)

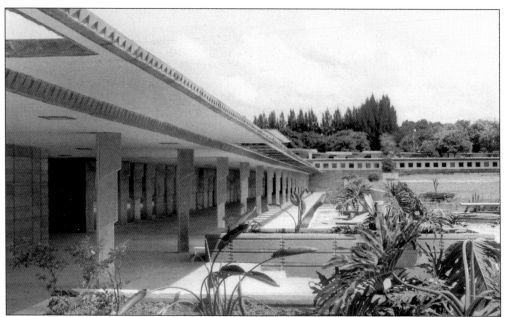

The aluminum columns supporting the loggia along the east side represent a relatively early use of aluminum as an architectural element. Beneath the aluminum sheaths are steel structural columns. Along the outside of the loggia, the columns are 18 feet apart at the centers, but along the glass wall of the building, they are 6 feet apart, in keeping with the mathematical rhythms of the spacing grid used by Frank Lloyd Wright. (Courtesy Florida Southern College.)

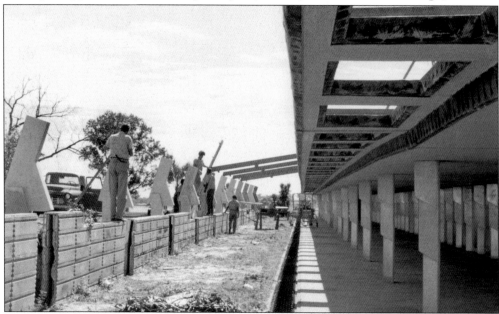

With windowless walls and only a relatively small skylight, the Frank Lloyd Wright–designed greenhouse at the end of the citrus section was neither large enough nor bright enough to support the work of the department. After unsuccessful attempts to have Wright's greenhouse space altered, the department successfully lobbied to have a large greenhouse constructed along the east side of the building. (Courtesy Florida Southern College.)

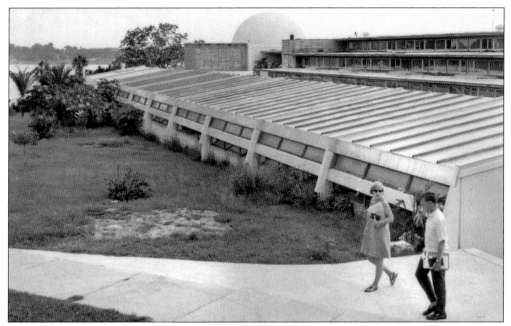

The greenhouse was designed in 1967 by Nils Schweizer. It was approximately 160 feet in length and was christened the William F. Ward Life Science Laboratory. Tongue in cheek, this unfortunate structure became known as the "Frank Lloyd Greenhouse." Smaller additions to this space were constructed by the late 1970s, and all were removed during the 1999–2000 renovation. (Courtesy Margaret L. Gilbert collection, Florida Southern College.)

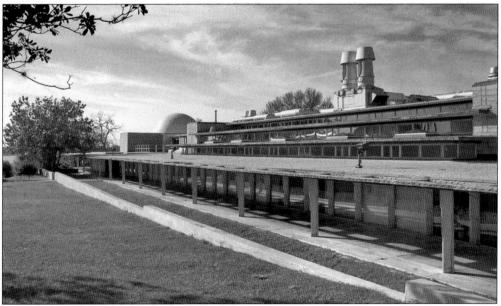

Despite the addition of the massive venting systems, the east facade of the Polk County Science Building was dramatically improved during the 1999–2000 renovation. Removal of the Nils Schweizer–designed greenhouse caused the building to more closely resemble Frank Lloyd Wright's original design. This photograph was taken near where a long ramp led upstairs to the mathematics classrooms prior to the renovation. (Courtesy William Carpenter.)

Frank Lloyd Wright's original greenhouse is accessible through interior rooms—and a narrow breezeway—of the citrus section, or from an external staircase on the south of the building, which leads to the breezeway. The greenhouse is now used to support botany classes. Perhaps underappreciated because of its functional shortcomings, the greenhouse remains a signal feature of the Child of the Sun campus collection. (Courtesy Florida Southern College.)

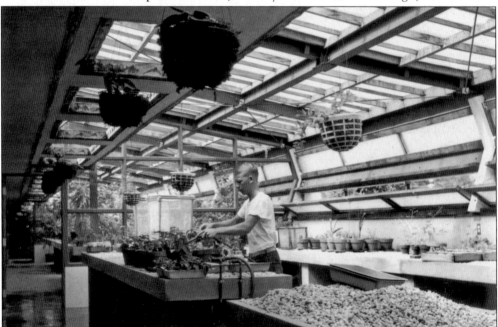

The Nils Schweizer–designed greenhouse, with subsequent additions, came to include a waterfall display room, an autoclave, and space for horticulture, botany, and citrus work. An animal room used by the biology department became home to a kinkajou found on campus in the late 1970s. After his 1981 arrival, Prof. Malcolm M. Manners cared for this shy but peaceful nocturnal animal for more than a decade. (Courtesy Margaret L. Gilbert Collection, Florida Southern College.)

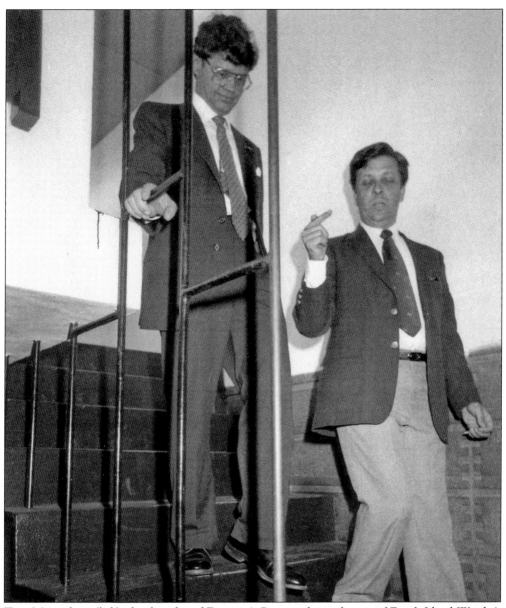

Tom Monaghan (left), the founder of Domino's Pizza and an admirer of Frank Lloyd Wright's architecture, was honorary chancellor of Florida Southern College in 1986. Here he is walking in the Polk County Science Building with Ray Fischer, who then was director of public relations for the college and a key figure in beginning the renovation and restoration of Wright's buildings. One of the problems with Wright's tapestry block construction has been that the cement poured into the grooves between the blocks, which was intended to cover the reinforcing rods, often did not penetrate the full length of the grooves. Sometimes the reinforcing bars were left lying uncovered in the bottom of the grooves where they were exposed to accumulated moisture, causing them to rust and then to expand hydraulically, cracking the blocks. A 2007 renovation project removed layers of paint from the Esplanade, identified and repaired hairline cracks by injecting a flexible epoxy under pressure into these voids, and repainted the Esplanade to match its original appearance. (Courtesy Florida Southern College.)

The Spitz 1024 planetarium instrument was a gift from John R. Miller II and his wife, Eleanor Honeyman Miller, in 2001 and is installed in the Miller Planetarium. The circular auditorium retains its original Frank Lloyd Wright–designed seating. The planetarium is a popular venue for astronomy course demonstrations and community programs. (Courtesy Nora E. Galbraith.)

The biology and chemistry wing of the Polk County Science Building has a distinctive, red concrete dual-level hallway, which is open to the second floor. For many years, wildlife mounts were displayed high along the west wall. This south-facing photograph is from the 1958 *Interlachen* yearbook. The 1999–2000 renovation altered the look of the hallway with the addition of metal ventilation shafts. (Courtesy Florida Southern College.)

Rubert W. Prevatt teaches a citrus culture course *c.* 1980 in PS 107, a classroom in the southeast corner of the citrus section of the Polk County Science Building. The classroom was close to the original Frank Lloyd Wright greenhouse and was restructured during the 1999–2000 renovation project. (Courtesy Florida Southern College.)

The PS 132 classroom last served as a botany and plant physiology lab but no longer exists as a classroom space following the major renovation. The curious human form, at right, was "Neon Man," created in 1954 by Florida Southern professors Roy S. Kiser and John Ireland to show the relationships "between the internal organs and the main arterial-veinous passages." (Courtesy Paul Wille, Florida Southern College.)

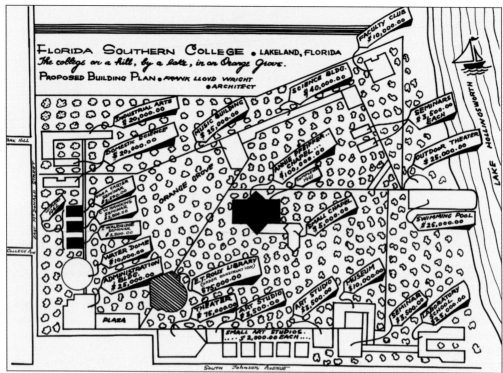

Frank Lloyd Wright's original plan for the Child of the Sun campus collection envisioned 18 structures. This map, from a World War II–era promotional brochure, represents a faithful interpretation of Wright's most expansive plan. The map shows 30 unique structures, including the Esplanade, and price tags for each. Of particular interest are the costs shown for completed structures: the Annie Pfeiffer Chapel, $100,000 (completed 1941); the three seminar buildings, $3,500 apiece (completed 1942); and projected costs for structures eventually completed in some form: the E. T. Roux Library, $75,000 (under construction when this map was published); the J. Edgar Wall Waterdome, $10,000; a single administration building and plaza, $25,000; an industrial arts building, $20,000; a small chapel, $5,000; and a science building, $40,000. Structures not completed include two domestic science buildings, $20,000; a music building, $25,000; a faculty club, $10,000; two lakeside seminars, $3,500 each; an outdoor theater, $25,000; a swimming pool, $25,000; a laboratory school, $25,000; a seminar on Johnson Avenue, $3,500; a museum, $10,000; two large and five small art studios, $3,500 and $2,000 respectively; and a theater, $75,000. (Courtesy Florida Southern College.)

Bibliography

Fischer, Ray. "Through the Years: Reflection on Frank Lloyd Wright."

"Florida Southern College Revisited for Glimpses of the Administration Group in Wright's Organic Campus." *Architectural Forum* 97.3 (1952): 120–127.

Haggard, Theodore M. *Florida Southern College, Lakeland Florida: The First 100 Years, An Illustrated History, 1985.* Lakeland, FL: Florida Southern College Press, 1985.

Horwitz, Hattie Schindler. "The West Campus at Florida Southern College, Lakeland, Florida, and its Builders." Miami, FL: University of Miami, 1976.

Interlachen. Lakeland, FL: Florida Southern College.

The Ledger. Lakeland, FL.

Little, J. Rodney, and Phillip A. Werndli. *National Register of Historic Places Inventory: Nomination Form for Florida Southern College Architectural District.* Tallahassee: Florida Division of Archives, History, and Records Management, 1975.

Mack, Thomas B. *History of the Citrus Institute at Florida Southern College, 1947-1993.* Lakeland, FL: Thomas B. Mack Citrus Archives, Florida Southern College, 1993.

Pearson, Andrew L., Lidia Gandarias-Llanos, and Lydia Lane. *Wright Chronicles: A Compilation of Correspondence, Telegrams, and Notes on the Buildings of Frank Lloyd Wright at Florida Southern College.* Lakeland, FL: Florida Southern College Library, 2006.

Rogers, Steven B. "The Frank Lloyd Wright Campus at Florida Southern College: A Child of the Sun." *Frank Lloyd Wright Quarterly* 12.3 (2001): 4–23.

The Southern. Lakeland, FL: Florida Southern College.

Storrer, William Allin. *The Frank Lloyd Wright Companion.* Chicago: University of Chicago Press, 1993.

Teeter, Carroll. "Frank Lloyd Wright Designs Modernistic Chapel at Lakeland." *Dixie Contractor.* April 16, 1941: 5-6.

Thrift, Charles T. Jr., ed. *Of Fact and Fancy . . . at Florida Southern College.* Lakeland, FL: Florida Southern College Press, 1979.

Wright, Frank Lloyd. *An Autobiography.* New York: Longmans, Green and Company, 1932.

www.arcadiapublishing.com

Discover books about the town where you grew up, the cities where your friends and families live, the town where your parents met, or even that retirement spot you've been dreaming about. Our Web site provides history lovers with exclusive deals, advanced notification about new titles, e-mail alerts of author events, and much more.

MADE IN THE USA

Arcadia Publishing, the leading local history publisher in the United States, is committed to making history accessible and meaningful through publishing books that celebrate and preserve the heritage of America's people and places. Consistent with our mission to preserve history on a local level, this book was printed in South Carolina on American-made paper and manufactured entirely in the United States.

This book carries the accredited Forest Stewardship Council (FSC) label and is printed on 100 percent FSC-certified paper. Products carrying the FSC label are independently certified to assure consumers that they come from forests that are managed to meet the social, economic, and ecological needs of present and future generations.

FSC
Mixed Sources
Product group from well-managed forests and other controlled sources

Cert no. SW-COC-001530
www.fsc.org
© 1996 Forest Stewardship Council

Find Your Place in History.